Fearless Flourishing

A Step-by-Step Workbook for
Embellishing Your Hand-Lettering with
Swirls, Swoops, Swashes and More

Alissa Cl

Ulysses Press

Published in the United States by:
Ulysses Press
P.O. Box 3440
Berkeley, CA 94703
www.ulyssespress.com

ISBN: 978-1-61243-873-3
Library of Congress Control Number: 2018959577

Printed in the United States by Versa Press
10 9 8 7 6 5 4 3 2 1

Acquisitions editor: Bridget Thoreson
Managing editor: Claire Chun
Editor: Renee Rutledge
Proofreader: Shayna Keyles
Front cover design: Ashley Prine
Cover photo: © ale_es0/shutterstock.com
Interior design: Jake Flaherty

Distributed by Publishers Group West

Contents

G.R.O.W.

Luxuriantly

Introduction to Flourishing
From Terminology to Tools

Hi, I'm Alissa, the creative behind Feist & Flourish Modern Calligraphy. I'm so glad this book has found its way into your hands. If you're anything like me, you love lettering and you want to do it even better. Adding flourishes to letters is one way to do just that, and I can't wait to teach you all about it.

Flourishing has long been a special topic for me. In fact, flourishing is the reason I got into brush-lettering in the first place, though I didn't know to use that term at the time. Flashback to shortly after the birth of my first child. In the wee morning hours, I found myself rocking my very-much-awake babe with one hand and scrolling Instagram with the other to keep from nodding off. An image of a fabulously flourished piece of lettering stopped me mid-scroll. The swashes, swoops, and loops were delicate and whimsical, yet somehow also powerful and bold. Unlike the traditional calligraphy I had tried in my youth, this had a modern, clean feel. It spoke to my lay interest in typography as well as my skills in painting and illustration. It seemed approachable, and I loved the handmade quality of the lettering itself. Simply put, I was enamored. As I dove headlong into the hashtag #moderncalligraphy, I thought to myself, "I could do that!" After a few minutes of research, I promptly ordered a set of brush pens online, dreaming about my future flourishing prowess as I sleepily rocked my baby to sleep.

Of course, once I had my pens in hand, it was evident from my first shaky attempts at flourishing that I was going to have to learn the basics first. I put off the study of flourishing to learn to write and draw letters well. When it was time to revisit the art of the flourish, I didn't find many

resources on the topic, and truth be told, I was a little intimidated. I wanted to do it well, and I wasn't sure where to start.

I hear these same sentiments from other lettering learners all the time. Whenever I teach an in-person Learn to Letter workshop, the topic of flourishing constantly comes up. My inbox is full of people asking me how to level-up their lettering to start creating the beautiful, ornate, and complex designs they've seen elsewhere. A common theme across all these inquiries is that people feel intimidated by the topic of flourishing and aren't sure how to improve. Perhaps you find yourself in the same predicament: You love lettering but find your attempts at flourishing lack a "certain something" that you can't quite identify. My friend, you are not alone! There was a time when I felt the same, but with a lot of study, diligence, and practice, I grew in confidence and skill as I began to create highly flourished pieces that I loved.

In its generic sense, the word "flourishing" refers to the thriving of plants to become lush and full, blooming and flowering in luxurious abundance. Now, of course, we know that's not the kind of flourishing we are talking about here. This book is not about plants; it is about all the swashy, swoopy, loopy strokes that lettering artists add to their work to make it look so spectacular. But when lettering is flourished well, it does seem to "bloom" and "flower" in abundance. There's a certain fullness and luxuriousness to well-flourished works. I've often thought of this botanical imagery in my own study of the flourish (indeed, even a cursory look at my Instagram feed will reveal my love for all things floral-inspired!).

I chose the word "flourish" to figure prominently in my business name, Feist & Flourish Modern Calligraphy, because I love its many meanings. As a lettering artist and modern calligraphy instructor, obviously I'm smitten with the act of adding flourishes to letters and words. But the notion of human flourishing also resonates with me deeply. It's a word that evokes fullness and life. When one is truly thriving (as a person, and as a creative), fear is replaced with joy. This deep sense of flourishing is something I hope we all experience in our day to day, in our creative pursuits and, of course, in our study here of flourished lettering.

If you're looking to thrive as a letterer and fearlessly master the art of the flourish, this step-by-step workbook is for you! It's all about helping you to grow luxuriantly and fearlessly in your flourishing skills. You'll learn to bedeck and beautify letterforms, adorn and embellish words, and glamorize finished pieces, all with the goal of growing your hand-lettered work into something truly spectacular. With a little diligent practice and some focused study, you'll be well on your way to confidently flourishing your own hand-lettered works.

Flourishing Defined

People often tell me that their messy handwriting makes them fearful to even try calligraphy or hand-lettering. If you've thought the same thing, you're not alone. It's a common misconception that lettering is simply the act of writing; in fact, it is more akin to illustration, and this shift in thinking is key for lettering artists, especially beginners. At my in-person Learn to Letter workshops, I often remind my students to imagine they are drawing their letterforms rather than writing them, and this has never been truer than in the art of flourishing!

In hand-lettering, flourishing is the decoration or embellishment of letters and words with extravagant or fanciful curves and lines. It's a next-level skill set that adds intricacy, fills negative space, and gives hand-lettered work a serious wow factor. As with all modern calligraphy and brush-lettering, flourishing is the art of creating something uniquely lovely *in the moment*. As such, it's perfectly imperfect, created by hand in a particular time and place (this is why all hand-lettered works will feature slight imperfections, no matter how practiced or steady the artist's hand may be). Flourished work can be delicate, stately, whimsical, bold, funky, or elegant, and it's one of the best ways to develop a personal style and make your lettering stand out. And wow, is it ever addicting!

In this book I'll be writing about lettering and flourishing done with a pressure-sensitive brush pen or paintbrush (more on that to come). I recommend that you have a basic understanding of modern calligraphy or brush-lettering foundations before you start seriously flourishing your work. But even if you're just starting out with lettering, there are lots of ideas here that will work with the simplest of letter forms, or even your basic handwriting!

What's more, I've included a wide array of other ornamentation for your lettering. While these embellishments are not technically considered flourishes, they are in keeping with the spirit of flourishing, and in that way, work hand in hand with the style and application of the flourishes you'll learn in this book. Put it all together and you will be able to create some seriously stunning flourished and embellished lettering work!

For all its intricacy, the art of flourishing need not be intimidating. Even the most complex and detailed calligraphed pieces can be broken down into a series of basic strokes that have been repeated and combined. Together we'll learn and practice the basic strokes, movements, and skills needed to create your own unique flourishing style!

Brush-Lettering and Modern Calligraphy

You may be wondering why I keep referring to both brush-lettering and modern calligraphy. This is because they are not technically the same thing.

"Modern calligraphy" refers to a contemporary style of calligraphy that breaks from some of the regimented rules of the more traditional, time-honored styles. It can be done with a pointed dip pen or with brush pens and paintbrushes, but is generally limited to script styles that feature contrast between thick and thin strokes.

"Brush-lettering" is *any* lettering that is done with brush pens or a paintbrush. It's not limited to script styles, and can be contemporary or traditional.

If you're a little unsure of how to use these terms, you're not the only one. The definitions of modern calligraphy and brush-lettering can be somewhat nebulous, overlapping in some

ways (and not in others). Trying to understand the difference can be difficult, and there is even some disagreement between lettering artists!

That said, the techniques in this book can be used whether you are doing modern calligraphy or brush-lettering, or like me, some combination of both. (It is important to note that traditional calligraphy tends to follow much more prescriptive rules than those I will outline here in this book).

The focus of this book is hand-lettering created with brush pens or paintbrushes on paper, and you'll notice that throughout the book I will refer primarily to brush pens. Whenever I do so, you can safely substitute the word "paintbrush" in its place if you are using these techniques for watercolor lettering.

Beyond Brush-Lettering: Other Applications

Though our focus will be on brush-lettering created with brush pens and paintbrushes, there are a myriad of other ways to make use of the techniques in this book. The wonderful thing about lettering and flourishing is that there are endless applications and new forms with which to experiment. Once you've mastered the flourishing techniques in this book, I highly recommend you give the following applications a try:

- Bullet journaling

- Chalkboard lettering

- Embossing with an embossing pen and powder

- Faux calligraphy

- iPad or digital lettering

- Lettering on glass, canvas, or other surfaces

- Lettering with various inks

- Letterpress designs

- Pointed pen calligraphy

- Sign lettering with paint pens or brushes

Tool Kit

Never underestimate the power of quality tools. While it is true that good lettering can be created with anything (even a basic pencil), using cheap tools, such as brush pens that fray easily or papers that cause your ink to bleed, will be needlessly frustrating and may even hinder your progress. The good news is brush-lettering tools are generally quite affordable. The supply list that follows is fairly exhaustive because I want you to have a comprehensive tool kit to draw from. However, all you really need to get started is a pencil, eraser, smooth paper, and one brush pen.

Because brush-lettering can be done with brush pens or with paintbrushes, as in watercolor calligraphy, I've given you a list for both, as well as a list of supplies for creating drafts of your designs.

Flourishing Your Lettering with Brush Pens

Brush Pens. These pressure-sensitive markers with flexible nylon tips allow for strokes of varying thickness. Use them to create thick, robust downstrokes and thin, hairline upstrokes in letters and flourishes. For beginners I recommend Tombow Fudenosuke brush pens with hard or soft tips for smaller work, and Tombow Dual brush pens for larger work. Note that harder tips will be easiest to manage for those just starting out.

> TIP: Holding the pen at a 45-degree angle to the page, apply lots of pressure when the pen moves down (for downstrokes), and apply very little pressure when the pen moves up (for upstrokes).

Monoline Pen. Use these for simple or graphic elements that do not need variation in thickness. My favorite is the Tombow Mono Twin.

Paint Pen. Use these in metallic or white tones for creating special effects, for writing on dark paper, or for writing over dark ink. I love the Molotov Liquid Chrome pen for a silver mirror-like finish, or Sharpie paint pens in metallic or white. Note that these pens are not pressure sensitive and will write in monoline, with no contrast between thick and thin.

> TIP: To achieve a contrast between thick and thin strokes with specialty pens that are not pressure sensitive, create "faux calligraphy" lettering by writing the word in monoline, then going back and filling in the areas that should have thick downstrokes.

Fearless Flourishing

Smooth Paper. Choose paper with as little "tooth" as possible. It will help you achieve that effortless flow, as well as preserve the tips of your brush pens. Resist the urge to use regular printer paper, as it will fray your pen nibs. Some options are premium printer paper, marker paper, and smooth cardstock. HP Premium Choice LaserJet paper is my personal favorite for everyday use. Acid-free, archival-quality cardstock lends itself well to finished pieces—just make sure you choose the smoothest brand you can find.

If you really want to use a brush pen on paper that isn't ideal, such as in your agenda or bullet journal, feel free! Your pens are there to serve you and your purposes. Just remember that any pen used on non-smooth paper will fray much more quickly. I reserve a few pens for writing on my calendar, or even over watercolor paintings, which are done on extremely bumpy papers. I wrap washi tape around the pen ends to remind me which pens are for this use.

Tracing Paper. Use this translucent paper over guidelines on practice pages or to trace versions of design drafts as you move toward a good copy. With tracing paper, the smoother the better. I recommend Strathmore 300 Series tracing paper, as it takes ink well (no bleeding).

> **TIP:** You will find practice pages throughout this book, as well as blank practice sheets on pages 126 and 127. To preserve them for reuse, place a piece of tracing paper on top each time you go to use them! Or, you can make copies.

Grid Paper. An alternative to guidelines, this paper can assist with spacing during the drafting process. Whether you choose graph paper or dot grids is a matter of personal preference. I prefer Rhodia pads for the smoothness of the paper, and dot grids, as they provide more minimal guidelines for my work.

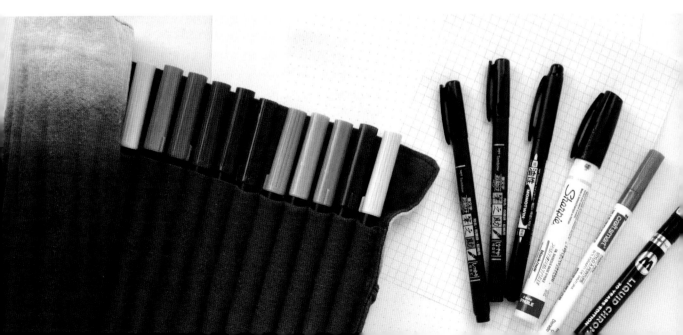

Flourishing Your Lettering with Watercolor Brushes

Throughout this book I will refer primarily to brush pens, but the tenets of brush pen lettering also apply to watercolor lettering. Feel free to practice the techniques in this book with both brush pens and watercolor brushes!

Watercolor Paintbrush. Use a small watercolor paintbrush for watercolor lettering. I recommend a no. 2 round brush for beginners.

Water Brush. With a reservoir that can be filled with water or liquid watercolor, this brush is particularly useful for lettering on the go or creating special effects, such as ombre lettering. I recommend the small or fine size brush tips and am partial to the Sakura Koi water brush for everyday use.

> **TIP:** Paintbrushes and water brushes work similarly to brush pens. Holding the paintbrush at a 45-degree angle to the page, apply lots of pressure when the brush moves down (for downstrokes), and apply very little pressure when the brush moves up (for upstrokes).

Watercolor Paper. Only for use with watercolor lettering, this toothy, fibrous paper will destroy your brush pen tips but take watercolor pigments beautifully. I recommend cold-press watercolor papers and am a fan of the Strathmore 400 Series watercolor pads for everyday use.

> **TIP:** Watercolor lettering doesn't work well on tracing paper, so when it comes time to use the practice pages in this book, use a pencil to create the guidelines on your watercolor page.

Watercolor Paint. Any watercolor set will do, but I prefer tube watercolors, with Winsor & Newton or Daniel Smith pigments being my favorites. Liquid watercolors, such as Dr. Ph Martin's Hydrus watercolors, work especially well with water brushes, as they can be poured into the barrel of the water brush, but note that their pigments are different and they move and blend differently on the page than tube or pan watercolors.

Metallic Watercolor Paint. Use metallic watercolors for special effects and finishes. I am partial to Finetec metallic gold watercolors.

Water Jars. Use two: one for rinsing cool-toned paints off your brush and the other for washing warm-toned paints off your brush. This will help keep your colors true and clean on the page.

Fearless Flourishing

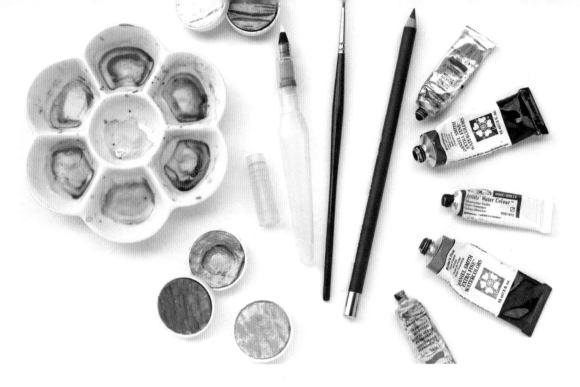

Mixing Dish. Use this for mixing pigments. A ceramic dish is better than a plastic one, as the water and pigment pools on it in a way that is easier to pick up with your brush, but both will work just fine.

Water-Soluble Pencil. The marks from this pencil will dissolve and vanish when you paint over them, making these pencils perfect for drafting your watercolor lettering pieces.

Supplies for Creating Design Drafts

Pencil. An absolute essential for drafting finished designs, a pencil will be one of your most-used supplies. Use pencils in the H range during drafting, as the harder lead will smudge less and is easier to erase.

Pencil Sharpener. Use this to keep your pencils nice and sharp for clean drafts.

Eraser. Another oft-used supply, erasers are indispensable in the drafting process. White plastic erasers work better than traditional pink erasers and leave less eraser dust. Black erasers work similarly but don't show the graphite smudges, so they always look like new. Light-touch erasers minimize paper damage and are a good option when you are working on a final copy. Sand erasers are a last resort, as they remove the top layer of paper, but are ideal when used sparingly for touch-ups on finished pieces. I'm a fan of Tombow's Mono line of erasers.

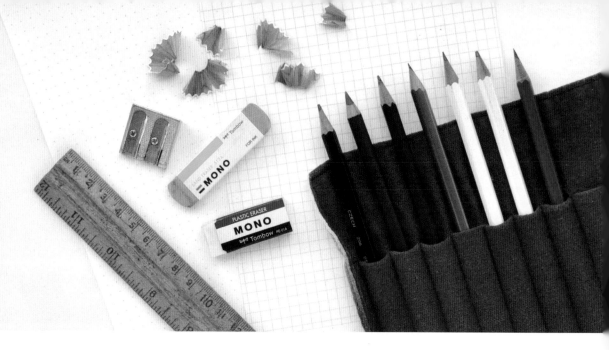

Ruler. Use this to lay out your design or create guidelines for your lettering and flourishes.

Compass. Use this to create circles or arcs as guidelines for your lettering during the drafting process. Compasses are often available to purchase inexpensively as part of geometry sets.

 TIP: No compass? Trace cups, bowls, or other round vessels to get that perfect curve.

Light box or light pad. With a translucent surface that is lit from behind, light boxes and light pads are useful during the drafting process and for creating final copies.

 TIP: No light box or light pad at your disposal? A window will do the trick! Or you can create a DIY light box by placing a light under a smooth, clear plastic container.

Review: Brush Pen Basics

Using brush pens or paintbrushes to create letters and flourishes is a basic skill for any brush-lettering artist or modern calligraphy student. Hopefully you are already familiar with the use of brush pens. Just in case you aren't, here's a very quick overview for using brush pens to create letters.

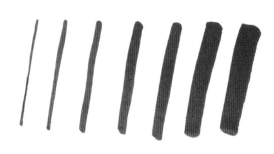

Fearless Flourishing

For a more in-depth study of brush pen use, I recommend you read a book, such as *Brush Pen Lettering* by Grace Song, or take a local workshop on beginner lettering.

Brush pens feature a flexible nylon tip that is pressure sensitive, meaning the tip is meant to bend significantly when pressure is applied to it, allowing for strokes of varying thickness. A brush pen tip is very resilient, meaning it will bounce back even with heavy pressure. My Learn to Letter workshop students are always amazed at how much the tip of the pen will bend in my demonstrations! The resiliency of the tip will generally take a long time to decrease, even with heavy use.

Though brush pens are resilient in their shape, the nylon fibers are prone to fraying when used incorrectly or with the wrong paper. You can read more about the specialized papers I recommend by flipping back to the Tool Kit section (page 10), but note that very smooth paper must be used in order to avoid fraying. The other way to avoid fraying the tip of your brush pens is to hold and use them correctly.

Brush pens must always be used at a 45-degree angle to the page. This is quite different from the vertical stance our regular writing instruments take. Start with your regular pen grip and see if you are comfortably able to hold the pen at a 45-degree angle to the page. If this grip is not comfortable, experiment with different hand positions until it feels good to write with the pen at that angle.

> **TIP:** Push the back end of the pen into the webbing between your pointer finger and thumb whenever you find the angle of the pen is creeping away from 45 degrees.

If you are left-handed, determine whether you are usually an "overwriter" (a leftie who writes with their hand curved up above their writing) or an "underwriter" (a leftie who writes with their hand directly below their writing), and experiment with different grips that still allow you to use the pen at a 45-degree angle to the page. Feel free to tilt the page counter-clockwise, experimenting with different angles, to assist you in finding a comfortable position. Some left-handed letterers also extend their elbows far to the left of their body, allowing more room to get to the end of the line before their arm bumps into their torso. You may have to try many different positions through trial and error until you are able to write comfortably with the pen at a 45-degree angle to the page.

Regardless of the hand you use to write, you will find that when you write with the pen at a 45-degree angle, you will be writing on the side of the nib. When you apply a lot of pressure, the nib will bend significantly, with more of the side of the nib touching the page, resulting

in a thick mark as you write. When you apply just a little pressure, the nib will bend a smaller amount, and less of the side of the nib will touch the page, resulting in a thin mark as you write.

As hinted at previously, the thick marks are called "downstrokes." Whenever your pen is moving in a downward motion, you will apply heavy pressure to the pen, resulting in a thick and robust downstroke. The thin marks are called "upstrokes," and as you can probably guess, they occur when your pen is moving in an upward direction. To do this, you will apply very light pressure to the pen, resulting in the thin, hairline upstroke. The tricky part comes in the release of pressure from thick to thin or the addition of pressure from thin to thick, especially when making curved strokes, such as in an oval. With a little diligent practice, the movements will become familiar and comfortable to execute.

All these principles are foundational for using brush pens to make brush letters, as well as to create beautiful flourishes. It's worth your time to learn these brush pen basics, as these skills form the basis of all good lettering practice.

Essential Terminology

In my Learn to Letter workshops, I've overheard all manner of gibberish used to talk about the parts of letters. The bowl of a letter P becomes known as a "rounded thingy on the right of the letter," while the swash on the leg of a K becomes a "swoopy loop-de-loop." It's always a laugh to hear what silly mumbo jumbo we come up with when we are talking about letter parts!

For clarity's sake, using correct terminology will be most helpful in our study of the flourish. Here are a few terms that are used frequently regarding lettering and flourishing. No need to memorize them; simply refer back here whenever you need a refresher!

Fearless Flourishing

Flourish: decoration or embellishment on letters and words with extravagant or sweeping curves and lines.

- Swash: embellished or exaggerated strokes in a letter, typically smaller or less decorative than a flourish.

Guideline: a template of lines used to create letters of uniform size and/or slant.

- Baseline: the bottom guideline on which most letters sit.
- X-height or Waist Line: the middle guideline, which is the height of most lowercase letters; it's named for the height of the letter x.
- Cap Height: the top guideline, which is the measure from the baseline to the top of most uppercase letters.

Ligature: two or more letters that are connected as one for decorative purposes or in cases of crowding, such as fl or tt combinations.

- Gadzook: the stroke that connects the letters of a ligature.

Monoline: letters or flourishes where all lines are of consistent weight (no variation or contrast between thick and thin).

Negative Space: the space within and around a letter, flourish, or illustration, stretching to the edge of the page or canvas; sometimes referred to as "white space."

Positive Space: the letters, flourishes, or illustrations that are the focus of the work or are the darkened/inked part of the work.

Stroke: specific mark made with a brush pen or paintbrush that forms a letter part.

- Apex: the top point where two strokes meet sharply, as with uppercase A.
- Ascender: the stem of lowercase letters that extends above the x-height up to the cap height; letters with ascenders include b, d, f, h, k, and l.
- Aperture: the outlet or opening of the space of an open counter.
- Axis: an imaginary vertical line that divides a letter in half.
- Ball Terminal: a stroke ending in a rounded shape for decorative purpose.
- Bowl: a rounded curve with a closed counter, as with lowercase p.
- Counter: interior space within a letter. Counters can be closed, as with lowercase o, or open, as with lowercase u.

- Cross Bar: a horizontal stroke that is closed in between two other strokes, as in uppercase H.
- Cross Stroke: a horizontal stroke that crosses a stem, as in lowercase t.
- Descender or Tail: the stem of mostly lowercase letters that extends below the baseline. Letters with descenders include lowercase g, j, p, q, y, z, and uppercase Q.
- Dot or Tittle: the dot of the lowercase i or j.
- Entrance Stroke or Lead-in Stroke: the beginning stroke of a letter, often used for connecting one letter to another.
- Exit Stroke: the ending or final stroke of a letter, often used for connecting one letter to another.
- Eye: the closed counter of lowercase e.
- Finial: a curved exit stroke that tapers, as with lowercase c.
- Foot: where a stem meets the baseline.
- Joint: where a stem and a stroke meet, as with uppercase L.
- Leg: a short stroke pointing downward, as with lowercase k.
- Petal Terminal: a stroke ending in a petal shape for decorative purpose.
- Stem: the main vertical stroke in most letters.
- Shoulder or Arch: an upward-curving stroke extending off the stem, as in lowercase h.
- Terminal: the end of the stroke in a letter or flourish.
- Terminal Curve: the final curve of a flourish, generally pointing back to the word itself.
- Serif: a short line placed perpendicularly at the end of strokes for decorative purpose.
- Vertex: the bottom point where two strokes meet sharply, as with lowercase v.

Fearless Flourishing

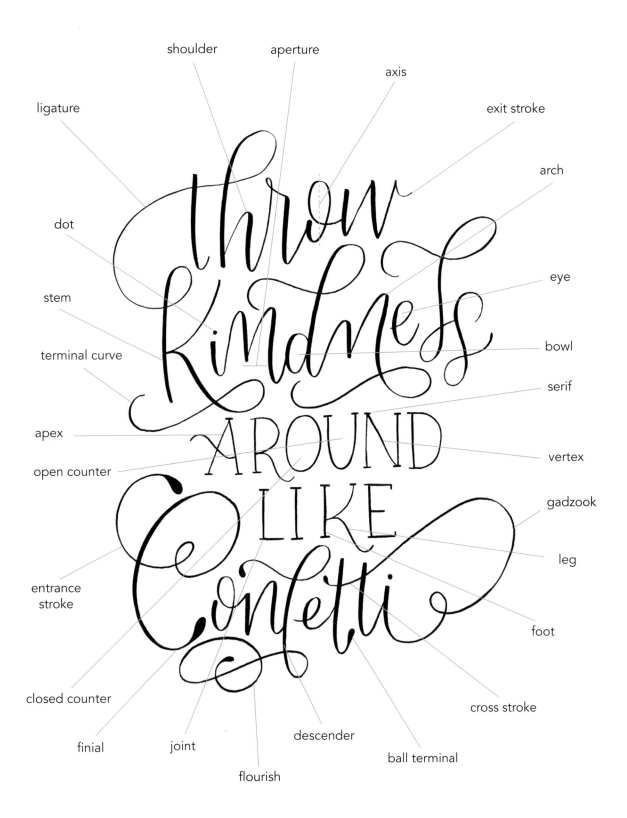

shoulder

aperture

axis

ligature

exit stroke

arch

dot

eye

stem

bowl

terminal curve

serif

apex

vertex

open counter

gadzook

leg

entrance
stroke

foot

closed counter

cross stroke

finial

joint

descender

ball terminal

flourish

Flourishing Basics
From Drills to Standalone Flourishes

Flourish Design Checklist

If you've tried your hand at flourishing at all, you know that there's a fine line between flourishes that work and those that don't. When I was first experimenting with embellishing my lettering, I found I was often unhappy with the results. When I evaluated my work, I could tell that something was off but couldn't quite figure out what it was. What's more, instead of augmenting my designs, the flourishes often detracted from the lettering itself! Likely, I was doing a combination of things that weren't working, and I wished I had a checklist of guiding principles to help me improve.

As I continued my study of the flourish, I compiled several fundamental guidelines that helped me create amazing flourishes that worked well in any layout. Instead of looking wonky, my flourishes started to look natural, well-spaced, and balanced. A culmination of dedicated study, this Flourish Design Checklist has helped me achieve beautiful results, and it will for you, too. We'll revisit these concepts often throughout this book. I suggest you keep a bookmark in this page so you can refer to it often as you practice.

Strive for that effortless flow. Flourishing should be fluid and free-flowing, with elegant lines and curves that appear smooth and natural. Use a light hand to achieve those delicate hairlines. Minimize tiny loops, straight lines, sharp edges, or hard corners in favor of flowing,

organic curves. Resist the urge to change directions within a single flourish too many times. Remember that simple oval and loop shapes form the basis for most flourishes!

Find the balance. Flourishing is all about balance. While a piece does not need to be perfectly symmetrical, aim for evenness in visual weight throughout the work. Ornamentation can be used to fill negative space or balance out large strokes in the letterforms, like ascenders and descenders. Use your critical eye to determine if there are spots that are too visually heavy and simplify as needed.

Keep it legible. In lettering, legibility is of utmost importance. Poorly executed flourishing can obscure the lettering itself. For beginners, I recommend keeping your flourishes entirely thin (or monoline), so that they do not distract from the letterforms of the piece. This results in a hierarchy between the word and the flourishes, increasing legibility. When flourishing is overdone, it interferes with the reader's ability to decipher letters and words. During the drafting phase, take a step back and assess whether the flourishing is enhancing the word or compromising its readability.

Maintain contrast. The contrast between thick and thin is what makes brush-lettering and modern calligraphy so striking, and it is key to keep that balance. When you do start experimenting with thick and thin strokes within each flourish, keep this in mind: Thick strokes should never cross one another, as the result is too visually heavy. That's not to say that your strokes will never cross in a flourish, just make sure one of the two strokes is a thin stroke. Remember: Thin and thin may cross, thick and thin may cross, but never thick and thick.

Utilize leading lines. The terminal of a flourish should generally point back to the letter, word, or passage that is being embellished. This will lead the eye back to the focal point of the work and is generally more pleasing to the eye!

Always remember, less is more. When you first learn to flourish, the temptation is to put elaborate embellishment everywhere! In fact, it seems like an oxymoron to say that ornamentation could be simple, doesn't it? As fun as flourishes are to add to a piece, it's generally good practice to use flourishes and other ornaments in moderation. Ask yourself if the piece calls for something intricate or more understated. If in doubt, err on the side of less. Good flourishing will always enhance your lettering, not conflict with it.

Pick your spots. Flourishes lend themselves to certain placements—the beginning and end of words, ascenders and descenders, cross strokes, and under or over words. We'll be going through each of these, but first, let's learn some basic strokes and do some drills.

Drills: How to Use the Practice Pages in This Book

It's my firm belief that drills are an essential practice for any hand-letterer, from beginner to advanced. I have fond memories of doing drills late into the evenings when I first picked up a brush pen. These days, disciplining myself to do drills is still part of my regular practice. Any time I spend doing drills benefits my craft and results in better work. Whenever I teach my in-person Learn to Letter workshops, I devote a large chunk of time to drills, because I believe they are just that important!

When you first learned to hand-letter, you probably started with basic strokes, practicing them over and over. If you kept at it, you discovered that you were developing muscle memory for the movements you were practicing. With repetition, the movements became easier and almost automatic.

Learning to flourish is much the same. Doing drills of some basic strokes will help you achieve that effortless flow by building muscle memory for each line and curve. When you're ready to move past the basic strokes, it's helpful to continue doing drills of more complex shapes. And, of course, don't be afraid to revisit the simple ones, especially if a certain shape or movement is giving you trouble. Going back to the basics from time to time will help you level up and gain mastery!

Fearless Flourishing

This book is filled with practice pages for that very reason. Use them to master the movements of each stroke and shape before moving on to the next. As you build on each skill, you'll soon find yourself creating the most complex and delightful flourishes!

Helpful hints for using the practice pages:

Draw in the air. Before you pick up a writing utensil, try making the movement in the air first. Use big, sweeping gestures with your whole arm until it feels comfortable. You may feel silly, but doing so will fire up your muscle memory before your pencil or pen even hits the page.

Start with a pencil. Ditch the brush pen for your first few tries; a pencil will allow you to focus entirely on the shapes you are drawing without having to worry about upstrokes and downstrokes (and, of course, it will also save your ink!). When the movements feel comfortable to execute, continue with your favorite brush pen.

Use arm vs. hand movement. Because flourishing can move in a variety of directions throughout a piece, it's helpful to use relaxed arm movement rather than hand or wrist movement. Resist the urge to plant your hand on the page for drills, as it may limit your movement too much to properly execute larger or more complicated flourishes.

Trace. Start by tracing directly over the exemplars using tracing paper. When you are ready, move on to creating them yourself on the tracing paper within the guidelines. Use tracing paper every time you use a practice page, so you can use the page repeatedly!

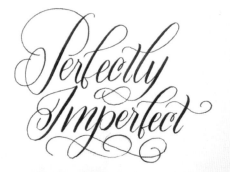

Go slow. Moving too fast will be detrimental to your progress. It's better to do only few of each stroke or shape well than to rush and risk learning them wrong. That said, the more you practice, the better; just make sure your movements stay slow and controlled.

Practice in all directions. The movements required for each shape will feel different depending on which direction the pen is moving, so it is useful to build muscle memory for flourishes in each direction. Don't be afraid to try drawing a shape in reverse or even upside down!

Rotate the page. Sometimes you may find it helpful to rotate the page from portrait to landscape, or to slant the page diagonally to complete some strokes. Feel free to do so if it will not cause an abrupt break in your lines or curves.

> **TIP:** It's a common misunderstanding that calligraphy is created in one continuous line. In fact, brush-letterers often lift their pen in the midst of writing letters or words, as long as the break in movement does not interrupt the flow of a stroke. Here's a good rule of thumb: Wait to lift your pen until the end of a complete stroke, particularly when the stroke is curving. For some letters, that may mean you will not be able to lift your pen at all. For others, you will find multiple opportunities to lift your pen, reposition, or take a breath before continuing to create the letter.

Add to your Personal Flourish Gallery. Use page 125 at the back of the book to keep a record of your favorite flourishes. It will be convenient to refer to this gallery later when you are drafting designs. You'll have all your best ideas at your fingertips! What's more, brainstorming variations and keeping a record of your best ideas will help you develop your own personal flourishing style. You can also keep this gallery in a separate notebook.

Be perfectly imperfect. Allow yourself to enjoy the process of learning new movements without pressuring yourself to do it perfectly. It's called hand-lettering for a reason: It's supposed to look like it was made by you, not a machine! Celebrate your improvements and keep a record of your progress. It will be very gratifying to look back and see how far you have come. While striving for that effortless

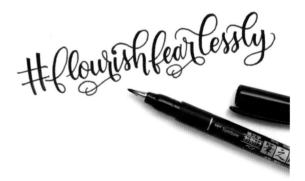

flow, also honor where you are in the process. Share your work with others and be proud of what you can do, no matter what stage you are at! And don't forget to tag your work with the hashtag #flourishfearlessly to show off your progress on social media!

Fearless Flourishing

A Note About Muscle Memory

At my in-person workshops, I always tell a story about when I learned to downhill ski. I was just seven years old when my dad took me to our local ski hill. Unlike my friends' parents, mine did not enroll me in a learn-to-ski class. In fact, my dad didn't even start me on the bunny hill. No, he put me at the top of a green run, briefly explained the basics of stopping with a snow plow maneuver, and gave me a push. I quickly learned to ski alright!

Admittedly, it wasn't long before I could ski down the hill with ease, and after a few years, to the untrained eye, I looked like a pretty great skier. But if the conditions were icy, the snow was slushy, or the run was steep and full of moguls, my form fell apart. I could get down the hill safely, but it didn't necessarily look pretty.

In my freshman year at university, I took a Skiing 101 class for an activity credit. My ski instructor noted that I intuitively did a few things well, but unfortunately had developed numerous bad habits that would be near impossible to unlearn without intense, focused training with a ski coach.

That's the power of muscle memory, and it's why I remind my students over and over again to work at a slow pace and always do their drills. I know you want to get right to the more complicated flourishes (they're the fun stuff, after all!), but the warm-ups, drills, and basic strokes are essential to achieve the muscle memory that will inform your flourishing work later in our study. Aim for slow, 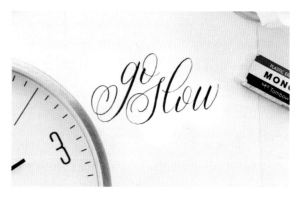 controlled movements with lots of repetition. When you're tempted to go fast or skip ahead, just think of me on the ski hill, and get back to those drills!

Warming Up

Before beginning a set of drills, it's important to warm up your hands, wrists, arms, and shoulders. Tense muscles will affect your lettering and flourishing for the worse. I like to do some wrist and arm circles that start small and get bigger, as well as shoulder raises. I usually finish with neck stretches, slowly moving each ear toward my shoulder. Any upper-body stretching

you can do will help, so feel free to use a combo of your favorite stretches. When you're feeling good and loose, it's time to make some basic marks on the page to get your hand really warmed up.

These warm-up exercises will familiarize you with the underlying movements of the basic strokes used to create both letters and flourishes. They'll also help you with consistency and give you that steady hand and smooth flow needed to create the curves and shapes in the next few sections. If you've already done some brush-lettering or modern calligraphy, these movements should be very familiar!

Try each of these exercises in pencil first. Once you've got the motion down, you can switch to a brush pen. Remember, keep your brush pen at roughly a 45-degree angle to the page, and try to re-create the same thickness of each stroke in the exemplar on page 28. Go slow and fill the entire line. The more repetition you do, the better your warm-up will prepare you for the flourishes you will create later!

Downstrokes. Downstrokes are meant to be thick and robust. Starting at the cap height, press firmly on the nib and draw it down toward the baseline.

Upstrokes. Upstrokes, also called hairlines, are meant to be thin and light. Starting at the baseline, lightly move your pen upward to the cap height while applying the slightest amount of pressure. If your pen skips and leaves a few blank areas, you may need to use slightly more pressure. Sometimes holding the pencil or pen a bit closer to the nib or raising its angle a little can help with stability.

> TIP: If your upstrokes are wiggly, try exhaling through the stroke. It's amazing how a forceful breath outward can help steady your hand!

Joined Upstrokes and Downstrokes. For this exercise, start with a diagonal upstroke. As you reach the cap height, feel free to lift your pencil or pen. Then, reposition and create a diagonal downstroke that goes from the cap height to the baseline, where you can lift your pencil or pen once again. If you'd prefer to create these strokes in one continuous movement, pay close attention to the release of pressure from thick to thin, as well as the transition to full pressure from thin to thick.

Overturns. Curvy strokes are essential for creating flowy flourishes, so the next few exercises are paramount. For this exercise, start with your pencil or pen at the baseline and create an upstroke that gently curves at the cap height, transitioning into a downstroke. Note that the

transition from thin to thick should occur at the axis of the letter, which is exactly in the middle of the overturn stroke.

Underturns. The reverse of the overturn stroke, underturns start with a downstroke. Position your pencil or pen at the cap height and begin with a thick downstroke that transitions at the baseline to an upstroke, which should continue back up to the cap height. Once again, the transition from thick to thin should occur at the axis of the letter, which is at the exact middle of the stroke.

Rolling Hills. This curvy movement is great for warming up your hand for the organic shapes in flourishing. Start with your pencil or pen at the baseline and create an overturn that transitions from thin to thick. As you create the downstroke, transition into an underturn. Do a few rolling overturn-to-underturn combinations, then lift your pen and start again.

Entrance Strokes. Entrance strokes are a great place to add a flourish, so it's a perfect stroke to warm up with. Position your pencil or pen at the baseline and make a gently curving upstroke that ends at the cap height.

Ascending Stem Loops. These letter parts are repeated often and are an obvious place to add a flourish. Practicing their basic form is a great warm-up and will prepare you for flourish variations later. Position your pen at the x-height, then create an upstroke that curves to the left and transitions to a downstroke at the cap height. Finish the movement with a thick downstroke that extends to the baseline.

Descending Stem Loops. Similar to the ascending stem loops you just practiced, these are created by positioning your pen at the x-height, then creating a downstroke that ends slightly lower than the baseline. As the movement continues, your pen will curve to the left, transitioning to an upstroke that joins the downstroke halfway between the baseline and the x-height.

TIP: Use a piece of tracing paper over the practice drill on page 28 so you can use it again and again!

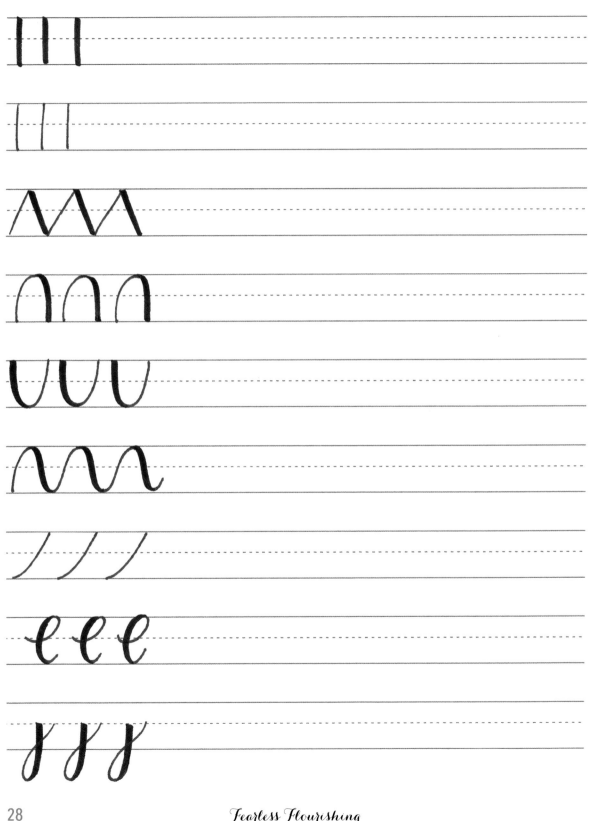

Fearless Flourishing

Basic Flourish Strokes

The most complex calligraphed designs are often much simpler than they appear. Almost all flourishing can be broken down into a set of simple strokes that have been combined and repeated. Many of these strokes do not have official names, but they all work together to create simply stunning flourishes.

Mastering these movements will result in much cleaner, more attractive flourishes, so resist the urge to start with more complicated designs. You'll thank me later! If you find you are struggling with a particular stroke, try doing a whole page of them. You'll be surprised how much you improve by the end of the page. Don't forget to start by tracing the exemplar with a pencil, and go slowly!

You'll notice that some of the exemplars on the following pages are in monoline. Monoline flourishes may be easier to learn than flourishes that have contrast between thick and thin. Being able to do both will give you options later when it comes time to draft more compli-cated pieces. In my own practice, I almost always choose monoline flourishes because I like the hierarchy it creates between the lettering and the flourishing. This choice is especially suited to pieces that call for simplicity or a light touch. They also enhance legibility, as the eye is less likely to confuse monoline flourishes for letters. Start with monoline and move on to flourishes with thick and thin variations when you are ready.

Once you've got a good feel for these movements, revisit them often. The more you practice them, the better your flourishing will look. Do a page of the basic flourish strokes any time you pick up your pen. They're a great warm-up and will always benefit your practice.

Ovals. Many flourishes are based on the oval shape, and this movement is often considered one of the trickiest to master. Starting at the cap height, transition early from thin to thick as you move your pencil or pen in a downward motion. At the baseline, do the same, transition-ing to thin, after which you will bring your pencil or pen back up to the cap height. This is done in one continuous motion, with the beginning and end of the stroke joining seamlessly. Don't worry if your ovals don't look quite right in the beginning. Unless you are an established brush-letterer, this will be a tough movement to get the hang of. Everyone feels a bit over-whelmed when they first try ovals! Keep practicing, go slowly, and don't give up. Try filling a whole page of ovals, practicing them in both directions. With repetition, you will find yourself creating lovely ovals in no time!

TIP: Some letterers like to start their ovals in the middle of the downstroke. As your pencil or pen comes around the top, you can hide the transition inside the downstroke! Others like to begin the oval at the 2 o'clock position of the upstroke. Try a few variations, and pick the strategy that works best for you.

Italic Ovals. Practice giving your ovals a bit of a forward lean, as sometimes this adds a nice stylistic touch to a flourish.

Horizontal S-curves. Also known as "swells," these lines feature a gentle curve in a subtle s-shape. Notice that s-curves start and end as a hairline but feature a robust center. Conversely, s-curves can also be made entirely as a hairline stroke, with no contrast between thick and thin.

Vertical S-curves. S-curves are mostly used in horizontal applications, but occasionally a vertical s-curve will be called for, especially when it comes time to attach flourishes to letters. Try it in both directions so you will be ready to use it when you need it.

Single Spirals. This is a basic move that will form the basis of the flourish work to come. Try single spirals that start on the outside edge (the biggest part of the spiral) and some that start in the center (the smallest part of the spiral). I've included spirals going in both directions, so you can move confidently in both directions when it comes to creating more complicated designs.

Double Spirals. Take the single spiral one step further with a double spiral. Here you will start in the middle of the first spiral, then create a gently curving line before creating a second spiral that turns in the opposite direction. Be sure to try it moving in both directions. Add an embellishment in the middle for a whimsical touch!

Stretched Double Spirals. Here the focus is a long, slightly curved line bookended by small, tight curls on each end.

Horizontal S-curve with Oval. Start with an s-curve, then move your pen upward to the cap height before finishing in an open oval shape.

Hooks. A hook is just a truncated spiral. Start at the top of a spiral, ending it before you complete the second internal spiral. Make sure you try it in both directions.

Spiral with Horizontal S-curve. Start with a simple spiral, then exit it with a horizontal s-curve. Practice it in both directions, as it is a common flourish shape.

Fearless Flourishing

Underturn Loops. These looping strokes feature a similar underturn stroke to those in your warm-ups. Do a few loops in a row and then lift your pencil or pen and start again!

Overturn Loops. Continue making loops, this time with an overturn direction. Try creating them larger and smaller and work in both directions.

Overlapping Loops. We'll explore overlapping flourishes in a future section, but now is a good time to try slightly overlapping your loops. Try to keep the overlapping bits even across the loops.

Italic Loops. Try giving your loops an italic lean, as this gives a different feel to some flourishes.

Stretched Loops. This time create a smaller loop with long, stretched-out connecting strokes.

Horizontal Open Figure 8s. This stroke is really just two s-curves that are attached. Unlike the classic figure 8 or infinity symbol, leave the end open.

Descending Figure 8s. This is a similar shape as the previous one, but this time the loop is repeated below the first.

Repeating Vertical Figure 8s. Similar to a script letter S in brush-lettering, this stroke can be repeated for a while before lifting your pencil or pen and starting over. Position your pencil or pen at the baseline, do an s-curve upstroke that goes up to the cap height, curve it back over, and do a vertical s-curve back down to the baseline. Repeat a few times, then lift your pencil or pen and start again.

Tear Drops. Also known as petals, these shapes will become very familiar when you start attaching flourishes to letters. Practice them in different sizes and orientations so you will be ready to add them to your future work.

TIP: Lift your wrist off the page to allow for fluid arm movement through the entire stroke.

All the strokes on the following practice pages will work together in different combinations to create intricate, stunning flourishes in the next sections. Before you move on, spend some time really mastering these movements. Don't fret if some movements don't come easily—everyone feels overwhelmed in the beginning! Keep working at it. Repetition is key to building muscle memory that will help you execute future flourishes with control and finesse. Once you're adept at these strokes, you will move on to some classic, standalone flourishes that will make your lettering work look spectacular!

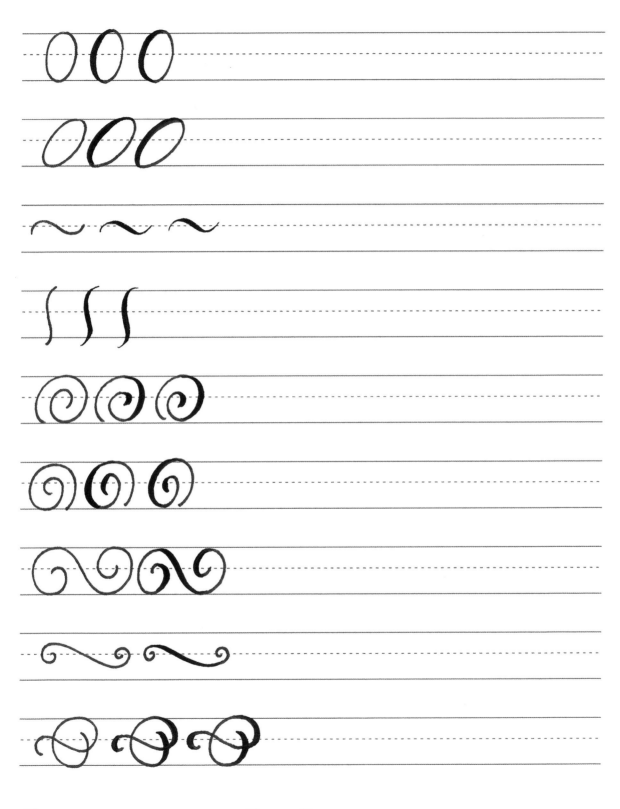

Fearless Flourishing

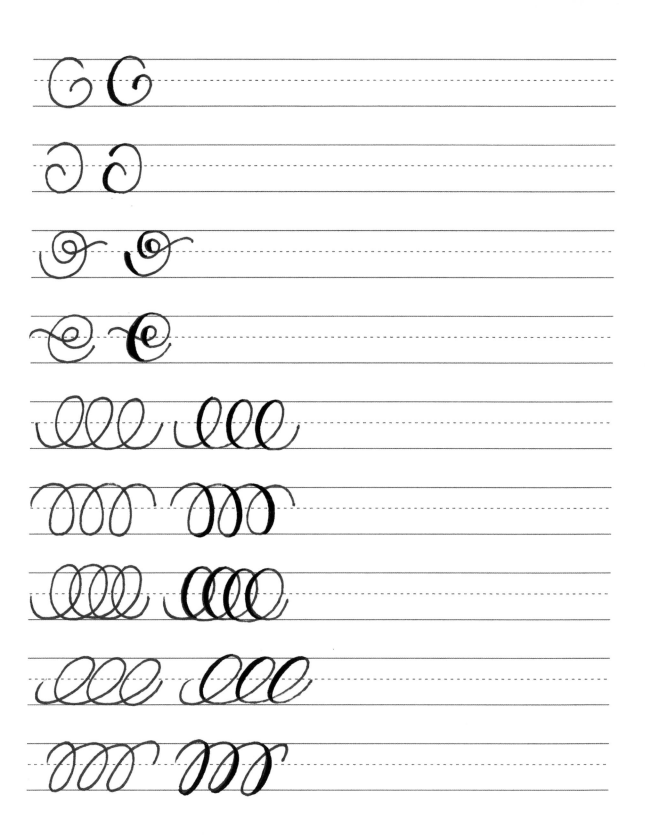

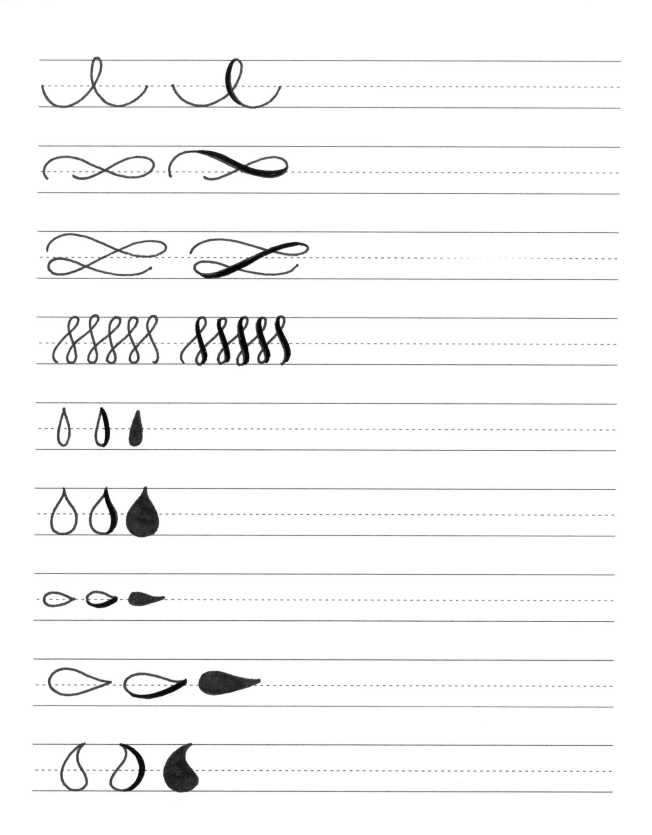

Fearless Flourishing

Simple, Classic, Standalone Flourishes

Now that you've mastered all the basic strokes, it's time to start combining them in interesting ways to create stunning standalone flourishes. The flourishes we'll go over here are simple and stately and don't need to be connected to letters. As such, they are fantastic starter flourishes. Place them under or over words, or fill negative spaces in your designs.

For these flourishes, you don't need to be as attentive to the lettering guidelines you are used to, like cap height, baseline, and x-height. Because these are standalone flourishes, they can be created in a variety of sizes and do not need to be connected to letters. Use the lines on pages 38 and 39 to help visualize the spacing within each flourish, but remember that you will tailor the size of these flourishes based on the needs of each individual design. You can combine the basic flourish strokes you just practiced or exaggerate and truncate different parts of each flourish to create something totally new.

Use the practice pages until you can do each flourish shape confidently and from memory. This way it will be easy to add them to your future designs. As always, use tracing paper and start with a pencil, then practice them with a brush pen or paintbrush. Practice each flourish going in both directions, and don't forget to try drawing them in the air. This technique can really help you master the fluid arm motions that lead to confident, fearless flourishing!

This list of flourishes is by no means an exhaustive one. As you practice, you should start to notice that the same basic strokes are repeated in different combinations. As you get more comfortable with each movement, you will no doubt begin to personalize them and even create your own styles. As you experiment, keep a record of your favorite flourishes in your Personal Flourish Gallery.

Descending Figure 8s. This flourish looks great below a single word, or under the last word in a vertical, stacked-word design. Start with the first s-curve of a figure 8 stroke, but as you loop back, bring your pencil or pen downward below the first s-curve. Continue making the figure 8 strokes go lower and lower down the page. Experiment with having the ends of the loops extend to different lengths. For example, the ends may decrease as they get lower, or they may start small and get larger before diminishing to a smaller size at the bottom.

Ascending Figure 8s. A mirror of the descending figure 8s we just practiced, this flourish looks great above a word, or at the top of a design, particularly when it acts like a bookend for a descending figure 8 at the bottom of a composition.

Descending Figure 8s with Large Spiral. Create the first half of a descending figure 8 but finish it with a large spiral at the bottom.

Descending Figure 8s with Ball Terminal. A familiar shape by now, but with the addition of a ball terminal.

Vertical Figure 8s with Spiral and Ball Terminal. This flourish looks great mirrored on either side of a piece. Create it by making vertical figure 8s that end in a spiral. Add a ball terminal for a stylized effect.

Double Spiral with Mini Spiral. Try embellishing the classic double spiral with a mini spiral on top of the line in the middle section.

Overturn Loops with Spiral. Create a series of overturn loops followed by a small spiral. The trick here is differentiating between the two main shapes by making the spiral much smaller than the loops.

S-curve with Open Oval. This flourish works great as an underline beneath a word or phrase, as well as mirrored on either side of a design. Create a horizontal s-curve that turns back into an open oval. You could also end with a spiral. Here this flourish shape is highlighted as a standalone flourish, but this shape is often also attached to letters.

Oval with S-curve, Spiral, Hook, and Ball Terminal. Create a large open oval followed by an s-curve that leads to a spiral. Exit the spiral by looping to change directions, and end with a small hook. Finish the flourish with a ball terminal on each end.

Loose Oval with Spiral and Two Hooks. Start this flourish with a small hook that leads into an s-curve. Move your pen downward as you transition into a large spiral. Exit the spiral by looping to change directions and end with a second hook.

Trumpet with Petals. Draw a horizontal straight line at x-height, then add two hooks or spirals, with one extending up and over the cap height and one extending below the baseline. Add a few teardrop or petal shapes inside the trumpet.

Descending Figure 8s with Two Hooks and Petal Terminals. Start at the top with a hook, then create a series of descending figure 8s. End with a second hook, and add petal terminals for decorative effect.

As the flourishes become more and more complex, it gets more difficult to describe them in words. After all, saying "small curve that goes into a large oval then changes direction and turns backward into a loop followed by a horizontal s-curve with a petal terminal" is a bit much, wouldn't you say? Hopefully by now you can see how all the basic strokes work together in endless variations, and are inspired to start trying your own variations!

Fearless Flourishing

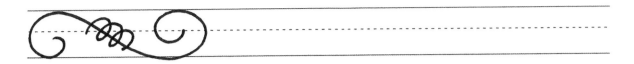

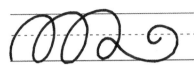

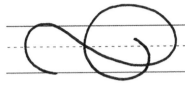

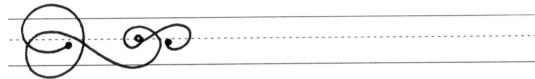

Overlapping Flourishes

So far, we have focused on standalone flourishes that don't interact with letters or with each other, but did you know that you can overlap your flourishes? Creating multiple flourishes that overlap can be an interesting design choice that adds intricacy to a composition. Done wrong, overlapping flourishes can look wonky, obscure the legibility of your lettering, affect the balance of your composition, or result in visual heaviness. For all these reasons, it's important to adhere to some simple guidelines when attempting to overlap your flourishes.

In the Flourish Design Checklist (page 20), this concept falls under the section about maintaining the tension between thick and thin. Anytime you cross strokes in a flourish, remember the following:

- Two thin strokes may cross.
- A thick stroke and a thin stroke may cross.
- A thick stroke and another thick stroke should NEVER cross.

Crossing two thick strokes creates a spot of visual heaviness in your design that is not pleasing to the eye. Brush-lettering and modern calligraphy are all about preserving the balance between thick and thin within each letter, and the same is true within each flourish, especially when two or more flourishes overlap.

Additionally, when overlapping flourishes, you'll want to keep an eye on the overall composition of your piece. Layouts never have to be symmetrical, but there should be an evenness and sense of counter-balance to your flourishes. Over time, you will get an intuitive feel for this balance, but in the meantime, keep these guidelines handy when you play with overlapping.

Double Pencils Trick

For an easy but dramatic flourish that mimics overlapping flourishes, try holding two pencils or pens in your hand while drawing your swirls and swooshes. You'll end up with perfectly doubled lines that look intricate and complex. Looking to make it even more ornate? Try this technique with three or even more writing utensils! The trick is to line them up evenly in your hand in such a way that they do not move from their position while you draw. This strategy can be utilized with any of the standalone flourishes you have already learned. Experiment and see what you can come up with on the dot grid. Once you've found some you like, transfer them to your Personal Flourish Gallery for future reference.

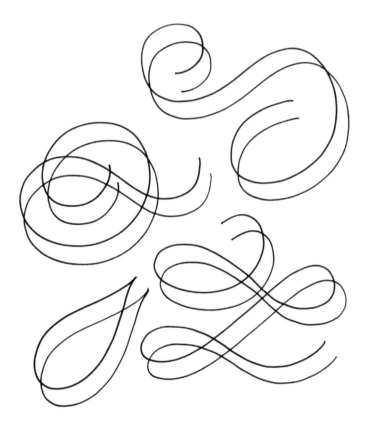

Experimenting with Variations

Now that you've got a feel for these flourishes, it's time to start making them your own. Choose a flourish from this chapter that feels comfortable and experiment with variations. Can you make it more elaborate or complex? What happens if you make it shorter or taller? Can you extend it in length or shorten it? Is there a place to change direction and create a new loop or swash?

Try filling the entire page. How many variations can you make? Don't worry if some of them look wonky. This is the time to experiment without concern for perfection.

Some other variations you might try:

- Exaggerating different parts of the flourish
- Stretching out your flourish so it is long and loosely drawn
- Truncating all or part of your flourish so it is small or tightly drawn
- Embellishing the terminal of the flourish with curls or petals
- Increasing the number or size of loops
- Gradually moving from large loops to smaller loops (and vice versa)
- Creating the flourish very large or very small
- Mirroring the flourish or creating it upside down
- Designing two flourishes that overlap in a visually pleasing way

When the page is full, examine each flourish. Which ones stand out as your favorites? Transfer these to your Personal Flourish Gallery. Hopefully by now you have developed some confidence in creating flourishes that look natural and lovely. Between the warm-ups, drills, basic flourish strokes, standalone flourishes, and all the style techniques you have learned, you already have a host of strategies at your disposal. Now, it's time to apply them in flourishes that attach to letters!

Flourishing Letters

From Lowercase to Uppercase and Everything Else

Connecting flourishes to letters is where things start to get really fun. You'll build on all the concepts and movements you've practiced already to start creating gorgeous letters and finished work that looks fantastic! As I noted at the beginning of the book, I do recommend that you have a basic understanding of modern calligraphy or brush-lettering foundations for this section. However, there are lots of ideas here that can work with simple, beginner-level lettering, or even with your regular handwriting. Feel free to adapt my tips to make them work for you, regardless of where you are in your lettering journey!

One of the most important tips for flourishing letters is this: Flourishes need to feel like they belong to the letter, like they are a natural and organic extension of the letter itself. This is as much a design decision as it is about having a smooth flow when creating the letters and flourishes. I will often sketch a letter in pencil first so I can try many variations before adding it to a design draft. Then, I'll practice it over and over until I can execute it smoothly and without hesitation before I use it in a final copy.

More than ever, you'll want to pay special attention to spacing. The shape, placement, and size of flourishes will differ depending on the specific letter you are writing. Avoid overcrowding, even when writing a single letter. You want each letter to breathe, so err on the side of giving more space rather than less. You may decide to refrain from connecting some letters in a word to leave more room near a flourish, particularly after a flourished capital letter.

These are not hard and fast rules. As you're working, stop to eyeball your lettering often. Finding the balance is not a matter of being mathematical or scientific, so trust your gut about the size of each swash and flourish you add. As you practice, the spacing of your flourishes will become more and more instinctual.

Before you jump into the alphabet, don't forget to review the Flourish Design Checklist. These principles become particularly important as you start flourishing letters and words. Here's a summary to jog your memory (or go back and read the principles in detail on page 20).

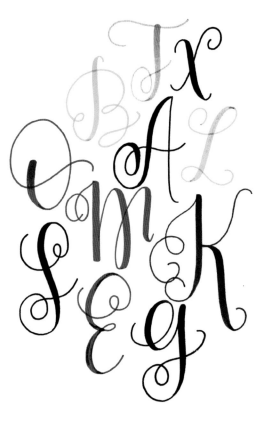

- Strive for that effortless flow.
- Find the balance.
- Keep it legible.
- Maintain the tension between thick and thin.
- Utilize leading lines.
- Remember, less is more.
- Pick your spots.

Flourishing Lowercase Letters

When starting out with flourishing, it's a common experience to want to put flourishes everywhere. But as I've already noted, less is more, and this is especially true with lowercase script letters. Because the letters are already attached to one another, there's not a lot of space left for flourishes. Instead of looking to flourish each letter, look for openings or opportunities to add carefully chosen swashes and swoops to some of the letters in a word. Of course, you may find yourself designing a piece with a single letter, in which case you will have the room to add more flourished elements.

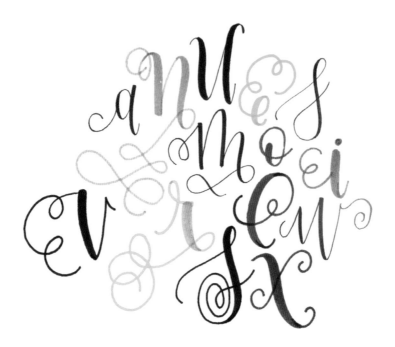

Regardless, it's helpful to practice flourishing each letter with several variations. You can always simplify when it comes time to create a complete design. Within the lowercase script alphabet, there are several obvious places to put flourished details. Let's go through them and get practicing!

Lowercase Ascenders

The ascending stem loop, the part of the letter that rises from the x-height to the cap height, soars high above most of the lowercase alphabet. As such, it's an easy place to add a flourish. The letters b, d, f, h, k, and l all extend with such a loop. The size and shape of the ascending stem loop can be adjusted, or you may choose to forgo the traditional loop shape for another shape altogether.

Let's take the letter f and try some variations. First, try writing the letter f in the usual way. The entrance stroke begins at the baseline and curves up into the loop. Try writing it again, but this time curve the entrance stroke in the other direction. Write it a third time, but start the entrance stroke at the cap-height. Look at all three examples and notice how the letter changes because of these small modifications.

Here are some other ways to make variations with an ascending stem loop:

Fearless Flourishing

- Exaggerate the shape of the ascending stem loop. Make it very skinny and delicate, make it fat and round, or use a teardrop shape.
- Lengthen the ascending stem loop above the cap height.
- Alter the shape of the entrance stroke; instead of a curvy entrance stroke, try a rounder, more circular stroke.
- Add one of the standalone flourishes you've learned to the beginning of the entrance stroke.
- Extend the entrance stroke into a long line that flows far to the left of the letter.
- Remove the loop altogether in favor of a straight or curving line that goes up to the cap height.

These variations work on a letter with an entrance stroke on the left side of the letter, but not all ascending stem loops work the same way.

Look at the letter d. There is a bowl on the left of the letter followed by a loop that goes up to the cap height and leads into the stem stroke. First, write it as you normally would. Write it again, but this time exaggerate the size of the loop by making it larger and rounder, and extending it above the cap height. Write it a third time, but enter the loop with a curvy line from the far left of the bowl, before looping around into the stem.

Try other variations from the list above, then examine the letters with a critical eye. How does each modification affect the feel of the letter? Do some variations appear more delicate or heavy? Are some more playful? Which version of the letter is your favorite? Paying attention to these stylistic considerations will help you develop your own style!

Flourishing Lowercase Descenders

Descending stem loops plunge below the baseline and offer many opportunities to add flourishes. The lowercase letters g, j, p, q, y, and z all feature a descending stem loop, which is one of my favorite places to add a flourish. As with the ascending stem loop, you can alter the size and shape of the loop to create a myriad of looks and styles.

Let's explore modifications to the letter j. First, write it as you usually would. Then, try writing it with an extra loop before the exit stroke to the right of the letter. Now, write it a third time, but this time curl the loop to exit to the left of the letter. Once

again, you can see that each modification makes a significant difference in the look and feel of the letter j.

Here are some other ways you could flourish a descending stem loop:

- Exaggerate the shape of the descending stem loop. Make it very skinny and delicate, make it fat and round, or use a teardrop shape.
- Lengthen the descending stem loop even lower than normal.
- Add one of the standalone flourishes you've learned to the exit stroke of the loop.
- Extend the exit stroke of the loop far to the left or right of the letter.
- Increase the number of loops or curls within the main loop.
- Extend the exit stroke of the loop up to the cap height, or have it curl up and around the letter.
- Forgo the loop altogether in favor of a straight or curving line.

Not all letters with descenders are created the same way. The letters p and q have a bowl attached to the descending stem loop.

Let's see what we can do with the letter p. First, write it as usual.
Next, try looping to the left of the letter. Now, write it again, this time extending the exit stroke of the loop to the right as a line that underlines the bowl of the p, and add an open oval shape. Doesn't that look lovely?

By now you should be noticing similar modifications that are repeated with comparable results. Try a few more of the alterations from the list above, paying attention to the shapes and styles that you like best. Then move on to the exemplars starting on page 55 to try flourishing the rest of the letters with descending stem loops.

Underline Flourishing

Underline flourishing is exactly what it sounds like. It happens when a descending stem loop is flourished in such a way as to extend across most of the length (or the entire length) below a word. While underline flourishing is often used with the letters y or g, as these letters frequently appear at the end of words, it really can be used with any letter that features a descending stem loop.

Consider the word "hooray." The descending stem loop of the y can be flourished with a loop and/or a line that runs the length of the word back toward the first letter. This can be a simple s-curved line, or you could attach one of the standalone flourishes you learned earlier.

Underline flourishing can also extend from the beginning of a word. Consider the word "yahoo." Here the descending stem loop of the letter y extends beneath the word to the right. Once again, it may be a simple s-curved line or it may be something more complex. If the flourish extends below the bulk of the word, it is considered an underline flourish. Using an underline flourish is a great stylistic tool and can help bring balance to a composition.

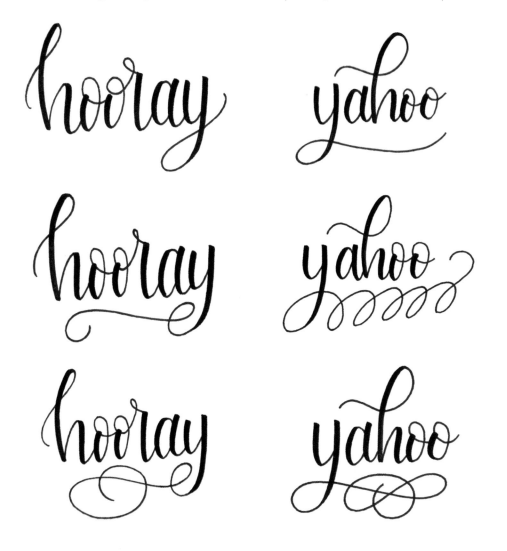

Cross Strokes

A cross stroke is the horizontal stroke that goes across the stem of the letter t (it may make an appearance in some versions of a lowercase f as well). The cross stroke is the perfect place to add a flourish, whether it be simple or ornate.

Try writing a simple letter t with a short, straight cross stroke. Write it a second time, but give the cross stroke a slight s-curve. For your third try, extend the cross stroke on one side and add a simple oval flourish. The opportunities for variations here are endless. Try a large flourish that goes up and over the letter, or a small flourish that dips down below the x-height.

Each of these adaptations results in a very different look. When it comes time to choose a cross stroke for a design, you'll need to consider the style of your overall piece, as well as the amount of white space you may have to fill, and choose accordingly.

Here are a few more ways to vary your cross strokes:

- Exaggerate the curve of the cross stroke.
- Attach a large flourish to one end.
- Experiment with overturn and underturn s-curves.
- Curve the cross stroke up and around near the cap height.
- Attach the cross stroke to another letter (this is called a ligature).

Ligatures

"Ligature" is a fancy word for joining two or more letters as one. This term does not refer to the normal way that letters are joined in cursive script. Rather, it describes significant modifications to letters that cause them to be attached in an unusual way. (And the line that connects the two letters, creating a ligature, is called a "gadzook," one of my favorite lettering terms!)

Ligatures are often used in the case of letter crowding. For example, the cross stroke of a lowercase t might interfere with the entrance stroke and ascending stem loop of a lowercase h, as in the word "the." Thus, the ligature of th comes into play—a simple solution to the problem of letter congestion.

More often, ligatures are simply used as a stylistic choice. Not only do they look cool, ligatures provide an opportunity to add complexity and originality to a design. And did I mention they are a great opportunity to add a unique flourish?

Let's take a look at the th combination I mentioned above.

Try writing th as you normally would. Now, try writing it with the cross stroke of the t extending and becoming the entrance stroke of the ascending stem loop of the h. Voila, a ligature! Try a third time, but this time exaggerate the size of the entrance stroke and ascending stem loop. For another option, start the cross stroke closer to the cap height and add a curl as you move into the cross stroke. Continue it by connecting to an exaggerated ascending stem loop on the h. Pretty fancy, right?

Cross strokes can almost always be turned into a ligature, and the letters don't need to be right beside each other in a word to do so. Consider the word "total." The cross stroke of the second t could rise above the a and join with the entrance stroke of the ascending stem loop of the l. Now, you might be tempted to join both ts and the lowercase l. However, depending on how it is executed, I would argue that this is potentially too much and might violate one of our Flourish Design Checklist principles. Nothing is worse than a forced or unnatural-looking ligature. Less is usually more, so be judicious when joining letters to create ligatures.

Ligatures are not limited to cross strokes, and there are many ways to create interesting ligatures. When you're drafting a design, look for opportunities to practice adding them.

> **TIP:** Ligatures are not limited to lowercase letters. Feel free to try joining upper and lowercase letters in ligatures if the design calls for it.

Double Letters

Sometimes double letters provide an interesting place for a flourish. A double t, for example, would allow for a ligature of the cross stroke. With a double s, you might exaggerate the loop on one of the two, or even the size of the entire letter s. For a double d, you might be inclined to flourish both, but in this case, I would choose one and keep the other un-flourished. As always, you want to

use flourishes thoughtfully and deliberately. As you find yourself drafting designs, be mindful that a double letter might be a place to consider adding an ornamental swash.

Entrance Stroke

The open space at each end of a word is an obvious place for flourishing, and entrance strokes in partic- ular can be varied in a few ways to excellent effect. Let's consider a lowercase w. Try writing it as you usu- ally would. The entrance stroke gently curves up from the baseline to the x-height. Try writing it again, but this time exaggerate the curve of the entrance stroke, perhaps even extending the length of the stroke from below the baseline. Now, write it a third time, but add a curl.

Here are a few other ways to flourish the entrance stroke:

- Start the entrance stroke from above and curve it around the letter.
- Extend the entrance stroke to begin from the very far left of the letter.
- Make the entrance stroke a large loop.
- Attach a standalone flourish to the beginning of the entrance stroke.
- Connect the entrance stroke with another letter to create a ligature.

Exit Stroke

Many of the same strategies you used for entrance strokes can be used for exit strokes. Consider the lowercase m. Try writing it with the usual exit stroke, a gently curving downstroke that goes from the

x-height to the baseline. Write it a second time, but extend the exit stroke to go below the baseline, and give it a small spiral. Finally, write it in the same manner as the second time, but curl the exit stroke under the letter and back toward the left, ending with a hook. With each example, the letter m gets more and more dramatic!

Here are a few other ways to flourish the exit stroke:

- Curve the exit stroke up and around the letter.
- Elongate the exit stroke far to the right of the letter.
- Make the exit stroke a large loop.

Fearless Flourishing

- Attach a standalone flourish to the end of the exit stroke.
- Connect the exit stroke with another letter to create a ligature.

TIP: In most words, you will not add a flourish to the exit strokes of individual letters, as you will be joining the letters together in close proximity. This means there is usually not enough space to add a flourish at the point of connection. What's more, a flourished exit stroke between letters in a word will likely obscure the legibility, as the viewer may read the flourish as a letter. Thus, lowercase exit strokes are usually used at the end of words or when flourishing a single letter.

Other Lowercase Letters

We've talked about lowercase letters with ascenders, descenders, and cross strokes, but what about the rest of the alphabet? The remaining letters don't fit into neat categories with their own names, but that doesn't mean there aren't plenty of ways to flourish them. As always, you want to be careful not to over-flourish lowercase letters, particularly when they are inside a word. Still, it's helpful to play with all the letters of the lowercase alphabet. You'll grow in your flourishing skills as you try different variations, and you'll have lots of ideas when it comes time to add these letters into a design draft.

a, c, e
For these letters, play with flourishes in the entrance and exit strokes, dipping below the baseline or curling up and around the x-height. Try adding extra curls to the top of the letter c, or exaggerate the eye of the letter e.

i
The dot, or tittle, of the lowercase i can be connected in a ligature. When the lowercase i stands alone, the entrance and exit strokes may be flourished.

m, n
Lowercase m and n have opportunities in the entrance and exit strokes. Exit strokes are particularly striking when they dip below the baseline and curve back into a flourish. Try adding extra loops to the entrance strokes of the m and n. With the lowercase m, you might consider exaggerating one of the shoulders, or arches, to be slightly higher than the other, particularly if the exit stroke dips below the baseline.

o, r

Lowercase o and r both feature loops that can be exaggerated in dramatic ways. The loop at the top of the r could be exaggerated for a playful effect. For both letters, consider the exit stroke. The exit stroke of the r could dip far below the baseline and attach to a larger flourish. The exit stroke of the o requires special consideration, as it needs to connect to the next letter in the word at varying heights, depending on which letter is next. Consider exaggerating the size of the loop on the o based on where the connection point of the next letter will be.

s

The lowercase s can be endlessly varied. Consider adding a loop, hook, or spiral at the top of the s. The exit stroke of the s can be quite swashy or contain an extra loop as well.

u, v, w

The letters u, v, and w have similar structures. If they stand alone, consider flourishing the entrance or exit strokes. The exit stroke of the u could extend below the baseline or curve into a flourish. The entrance stroke of a v could include a curl or curve up above the x-height. With a lowercase w, consider exaggerating the size of one of the open counters by dropping the bottom of it slightly below the baseline.

x

The letter x could be treated as a descender, with one of the strokes dipping below the base-line with a simple curve or even a more elaborate flourish. You could also add a loop to the top of a stroke or even extend it up past the x-height.

Now, try the whole alphabet. As usual, you may want to start with a pencil first. When you do try it with a brush pen, don't forget to maintain the balance of thick and thin within each letter. As you transition to the flourish, remember to release pressure so the flourish itself is a thin stroke. Once you are more comfortable with each letter, you can experiment with having thick downstrokes within the flourish. These practice pages feature three different variations for each letter, but the examples here are by no means exhaustive. As always, be sure to try your own variations and transfer your favorites to the Personal Flourish Gallery at the end of the book or in a separate notebook.

Fearless Flourishing

a a a

b b b

c c c

d d d

e e e

f f f

g g g

h h h

i i i

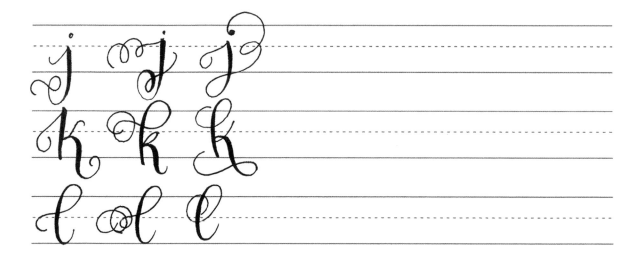

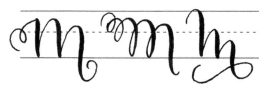

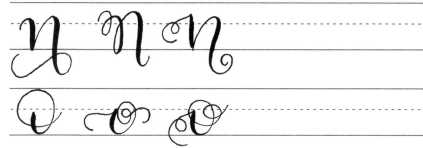

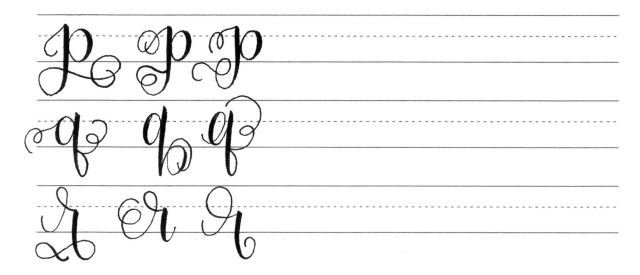

Fearless Flourishing

S S S

T T T

U U U

V V V

W W W

X X X

Y Y Y

Z Z Z

fearless

Flourishing Uppercase Letters

Highly flourished or ornamented capital letters are a striking stylistic choice. With so much white space at the beginning of the word, they are a natural spot to add significant embellishment. Have fun with flourished capitals, but don't get too carried away. As always, frequently check your work against the design principles on the Flourish Design Checklist (page 20), summarized here:

- Strive for that effortless flow.
- Find the balance.
- Keep it legible.
- Maintain the tension between thick and thin.
- Utilize leading lines.
- Remember, less is more.
- Pick your spots.

Sizing and Spacing of Flourished Capitals

Uppercase letters that feature significant flourishing are often referred to as flourished capitals. Because flourished capitals are often a focal point in a piece, you might consider exaggerating the size of these letters in your design. If you do so, it will be imperative to create balance in the other parts of the design using flourishes, ligatures, or other design elements. Upping the size is a great tool, but only use it when you think it is called for in the design.

Connecting uppercase letters to the lowercase letters that follow them can also be a sticky point. Plan for the connection point between the flourished capital and the next letter by leaving more space or even forgoing the connection point between them. This would mean the second letter may or may not feature its own entrance stroke.

Fearless Flourishing

These design decisions often come down to your personal style. As you continue practicing, you'll find that you gravitate toward a particular look and your decisions about spacing will become more and more intuitive.

Entrance Stroke

Like those of lowercase letters, the entrance strokes of uppercase letters provide a perfect opportunity to add some flourishes. Consider the letter H. Write it with a small overturn entrance stroke. Try it again, but this time with an underturn entrance stroke that starts above the cap height. Now, try adding a curl to one of these entrance strokes.

Here are some other ideas for flourished entrance strokes:

- Extend the entrance stroke far to the left of the letter.
- Vary the beginning by starting from the baseline, the x-height, the cap height, or above.
- Add extra loops or curls.
- Connect the entrance stroke to the foot of the letter.
- Curve the entrance stroke around the top or bottom of the letter.

Exit Stroke

Exit strokes are another place you can make alterations to uppercase letters. Simply extending the exit stroke on any letter can have dramatic effect. Play with different curve shapes or attach the simple flourishes you learned earlier to create that wow factor.

Some letters lend themselves to this more than others. Extending the exit stroke of the M, N, or K into a significant swash can have excellent results. Let's try the letter K. After writing it as you normally would, try extending the exit stroke down below the baseline and give it a slight hook. Now, write it again, but this time curl it back to the left of the letter and create an underline flourish.

When you have the space to work with, attaching more substantial flourishes to an exit stroke can be very striking and can be useful for filling negative space. Try adding extra loops to an underline flourish, or see if you can connect the exit stroke to another part of the letter in an interesting way.

Try these strategies for flourished exit strokes:

- Extend the exit stroke far to the right of the letter.
- Vary the ending of the stroke at the baseline, the x-height, the cap height, or above.
- Add extra loops or curls.
- Connect the exit stroke to a standalone flourish.
- Curve the exit stroke around the top or bottom of the letter.

Cross Bar

Another spot that is ripe for flourishing, the cross bar is a horizontal stroke that is closed in between two other strokes, such as in the letters A and H. It's different from a cross stroke, as cross strokes are not closed in on both sides.

Consider the letter A. First, write it as you usually would. Next, give the cross bar a gentle curve, and extend it a little further on each side. Now, write it a third time, and make the left side of the A curve into a curl that becomes the cross bar. This third variation of the letter A does not follow the rules of upstrokes and downstrokes. Normally you would treat the left side of the A as an upstroke. However, for this one variation, you will move your pen downward but keep the pressure light to make it appear like an upstroke, then create the curl that leads into the cross bar.

There are lots of ways to create interesting cross bars:

- Raise or lower the cross bar above or below the x-height.
- Curl the cross bar up to the cap height and around the letter.
- Use the cross bar to create a ligature with another part of the word.
- Put a curl directly in the middle of the cross bar.
- Attach a more elaborate flourish to the end of the cross bar.

Keep experimenting with cross bars, and I'm sure you'll think of some new ones that reflect your own personal style. Don't forget to add your favorites to your Personal Flourish Gallery!

Apex and Vertex

The apex is the point where two strokes meet (often sharply) at the cap height. We see it with the letters A, M, and N. If you are looking to create a more ornate style, you may choose to add a flourish that attaches at the apex.

The vertex is the point where two strokes meet at the base-line. We see it with the letters V, W, M, and N, and it can be flourished with extra loops, similar to the apex.

Try it with the letter M. First, write it as you usually would.
Next, write it again with small loops at each apex and the vertex, then try it with a loop only at the vertex.

Next try writing the letter W as you normally would. Now, write it again with two loops, one at each vertex, then write it with only a loop at the apex.

This organic style pairs well with other letters that feature extra loops. Whenever you choose to add loops to the apex or vertex of a letter, be on the lookout for other letters to add loops to. This will result in consistency across the design.

Descender

We tend to think of descenders as being limited to lowercase letters, but there are a few uppercase letters that feature them as well. The letters G, J, and Y have descending stem loops that can be embellished in a variety of ways.

First, write the letter Y as you usually would. Now, try writing it with an extra loop before making an exit stroke to the right of the letter. Write it a third time, but curl the loop to exit to the left of the letter and down.

Here are some other ways you could flourish a descending stem loop:

- Exaggerate the shape of the descending stem loop. Make it very skinny and delicate, make it fat and round, or use a teardrop shape.
- Lengthen the descending stem loop even lower than normal.
- Add a standalone flourish to the exit stroke of the loop.

- Extend the exit stroke of the loop far to the left or right of the letter.
- Increase the number of loops or curls within the main loop.
- Extend the exit stroke of the loop up to the cap height, or have it curl up and around the letter.

Stem

The stem is the main vertical downstroke that appears in most letters. Often a relatively straight stroke, this part of the letter can be altered in a few ways to great effect. Consider the letter D. Write it as you normally would, then try writing it with a stem that is unconnected to the rest of the letter and extended in length to the cap height and baseline. Try it again with the stem extending to the left at the baseline, and add a curl or two.

Here are a few more ways to embellish the stem of a letter:

- Loop the stem at the baseline to become part of the letter.
- Add a loop or curl at the top or bottom of the stem stroke.
- Add an s-curve to the right of the stem at the baseline.
- Experiment with straight or gently curving stem strokes.
- End the stem stroke with a dramatic loop and swash.
- Start the stem stroke well above the cap height and with a large overturn curve.

Oversized, Overlapping Flourishes on Uppercase Letters

Sometimes a flourish can get so big that it overlaps itself. This can be extremely dramatic but should be used sparingly, as overlapping done poorly can impede legibility. Some letters, like N, O, Q, V, and X, lend themselves especially well to this type of flourish.

Let's try it with the letter O. First, write it as you normally would, with a moderate-size loop at the top. Now, write it again with a significantly larger loop. For your third try, create a large loop for the entrance stroke, then create another loop inside it. These movements should be exaggerated and sweeping, and I recommend keeping the flourishes thin when you are just starting out.

Fearless Flourishing

Now, consider the V, which has a very different shape. Try writing it as your normally would, then try again, with a large curving entrance stroke. Write it a third time, but extend the last stroke above the cap height and curve it back around over the letter, slightly below the x-height.

Taken by itself, this letter is hard to read. The added flourish makes it difficult for the viewer to decode what letter they are looking at. However, when it is placed in a word or a longer sentence, you'll find the brain uses the context to identify it as a letter V. As always, it's crucial to use a critical eye when deciding whether to use a flourish of this nature. When in doubt, revise your design to be simpler.

Combining Techniques on Flourished Capitals

Many flourished capitals are created by combining the techniques we have discussed. By now you've got a wide array of flourishing ideas to work with. Don't be afraid to mix and match different strategies.

Consider the following methods:

- An exaggerated overturn entrance stroke with an extra loop
- A flourished stem with a loop at the baseline
- Overlapping between the entrance stroke and the stem
- A slightly curved downstroke on each side
- A curvy cross bar that loops back into the letter
- A gently curving exit stroke

It's time to try the variations of each letter in the practice pages. Have fun experimenting without the pressure of creating a finished piece. When in doubt, simplify and don't forget to pay attention to legibility. Save your favorite designs by transferring them to your Personal Flourish Gallery.

And don't forget to use your critical eye to evaluate your work. Refer back to the Flourish Design Checklist on page 20 often.

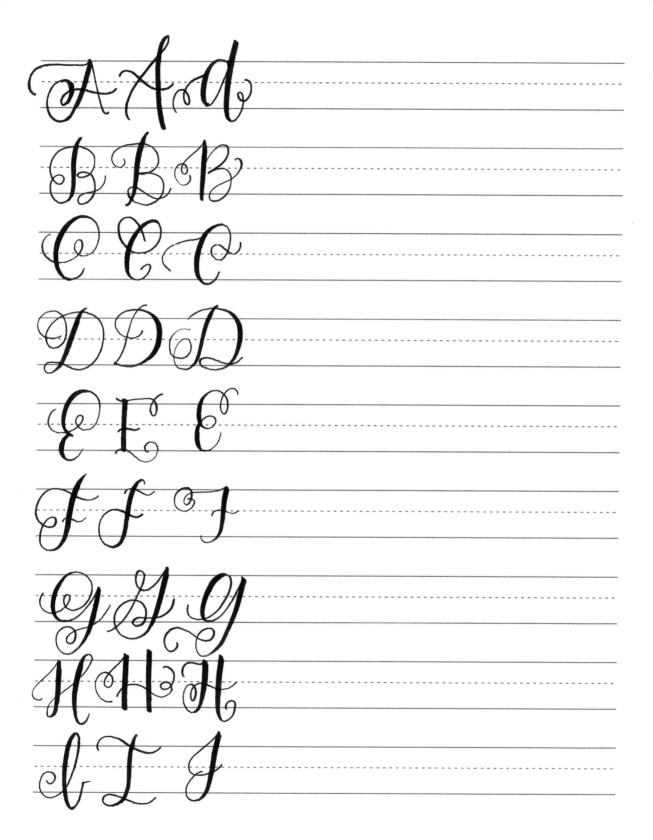

Fearless Flourishing

J J J J

K K K K

L L L L

M M M M

N N N N

O O O O

P P P P

Q Q Q Q

R R R R

S S S

T T T

U U U

V V V

W W W

X X X

Y Y Y

Z Z Z

FEARLESS

Fantastical, Unexpectedly Whimsical Flourished Letters

We've covered all manner of flourished letters in both upper and lowercase. We've considered obvious spots for flourishes and patterns of flourishing that occur repeatedly on many different letterforms. But let's take a moment to consider those letters that surprise us with unique, unexpected flourish styles. Occurring in both upper and lowercase, these fantastically flourished letters are almost outlandish in their ornate flourishing. Fun and unexpected, they deserve to be recognized!

Letters that are flourished with this level of whimsy come with lots of practice and experimentation. When I am stuck for a letter, I often write it over and over as I brainstorm different ideas for flourishing

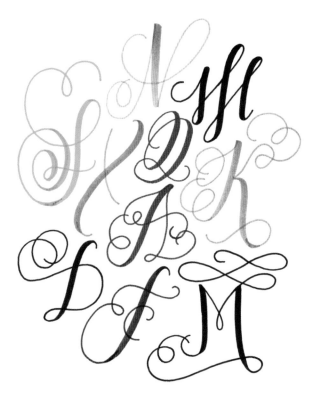

it, and that's how some of these whimsical flourish variations came to be! Filling an entire page with variations on a single letter can be a rich creative exercise, an excellent hand warm-up, and a way to come up with a variety of new and wonderful flourish styles. Give it a try on the dot grid! Don't be afraid to experiment or try wild ideas. When you've filled the page, take a moment to examine your work. Which styles worked best? Which didn't work? Which are your favorites? Transfer the best ones to your Personal Flourish Gallery at the back of the book or in a separate notebook to inspire future work.

FOUR

Flourishing Words and Phrases

Now that you're well-versed in adding flourishes to individual letters, it's time to put it all together in full words. Letters that are joined together well form the foundation for great flourishing. It doesn't matter how lovely your flourishes may be if the word you add them to looks wonky. Keep practicing the warm-up strokes and basic strokes, as well as your letterforms. Continually improving your lettering will set you up for success in flourishing.

> **TIP:** Hopefully, joining letters in script is familiar to you, as it is a basic skill in brush-lettering and modern calligraphy. If you'd like to do an in-depth study of joining letters, I suggest you consult a book, such as *Brush Pen Lettering* by Grace Song, or take a workshop on lettering for beginners.

When it comes to writing full words, the first and last letters will generally be the most flourished. In the interest of legibility, it's best to keep lowercase letters within a word fairly simple. Because they are in close proximity, there's not much room for flourishes. What's more, extra loops and swoops can confuse the reader, as the brain might read the embellishments as potential letters. So, to start, focus on flourishing the first letter and the exit stroke of the last letter.

If the first letter of your word is uppercase, it's the perfect opportunity to use one of the flourished capitals you practiced earlier. Note that the letters that directly follow a flourished

Fearless Flourishing

capital are often not joined to it. While it's not a necessity to leave this space, leaving the letters unconnected can allow highly flourished uppercase letters to "breathe." When you decide whether to connect them, consider the design as a whole. What will make the design more cohesive?

Linking lowercase letters within a word is all about the entrance and exit strokes. Most of the time you'll leave the flourishes off these strokes and simply write each letter with its basic or simplest stroke variation. Then, you'll create the next letter in the word by overlapping the entrance stroke (or in some cases, the leftmost part of the letter) with the exit stroke of the preceding letter. Remember, it is a misconception that script brush-lettering is created in a single, continuous line. After each exit stroke, you will lift your pen, reposition it for the next letter, then create it on the page so that it overlaps or joins the previous exit stroke. Do this with every letter in the word and you will have written a full word!

As you write a word, focus your attention on achieving even spacing. One trick for improving spacing is to practice extending the exit strokes of your letters. Whenever you do letter drills, make the exit strokes slightly longer than you would normally, and carry this practice over into your words. When you're writing a word, the extended exit strokes should be roughly similar in length. By joining each letter with exit strokes of a similar length, you should see a fairly even pattern of spacing develop.

> **TIP:** Exit strokes joining lowercase letters together within a word should be a similar but not identical in length. This is because spacing is less about mathematics and more about what is visually pleasing to the eye. Some letters will look better if they are placed closer to one another while others may need to be spaced farther apart. In typography, this is called kerning. Brush-lettering and modern calligraphy do not technically fall under the umbrella of typography, but the idea of kerning is still a helpful one. Use your critical eye to make adjustments that allow for the spacing of your letters to be visually pleasing.

Note that some letters will need to be formed with special care in order to attach to the next letter. Consider the lowercase o. If it is followed by the letter n, as in the word "on," the exit stroke will have to end up at the x-height. If the letter o is followed by the letter f, as in the word "of," the exit stroke will need to end closer to the baseline. This will affect the way the letter o is formed. The looping stroke at the top of the o might be exaggerated and brought low or it might be minimized and kept up

high. It's good practice to think about the word as a whole *before* you start writing, so you can anticipate these tricky connection points.

While we keep the entrance and exit strokes fairly simple within a word, there are still places to add flourishes to lowercase letters. Now is the time to extend the exit stroke of a lowercase r into a flourish, or to give a lowercase k an exaggerated swash. You might add flourished variations to ascending stem loops and descending stem loops, or place standalone flourishes under or over a word.

I noted earlier that the lowercase letters following a flourished capital might not be joined to it. Occasionally, you might also choose to forego a connection between the lowercase letters within a word, though I recommend doing this sparingly. While most script brush-lettering is joined, there may be a spot where not connecting two letters enhances the flow, particularly following a flourish. For example, a letter that follows a highly flourished lowercase r will likely look better if it is unattached, allowing some space around the flourish.

As I've touched on already, spacing in hand-lettering and modern calligraphy is not an exact science. Instead, you'll need to eyeball your work often, adjusting it to get the flow of the letters just right. The spacing of letters within a word will become more intuitive with practice, which is good news, because it's a skill that supports your flourishing practice.

TIP: What about spacing in between words? There is no hard and fast rule at play here, particularly because modern calligraphy and brush-lettering often feature exaggerated sizing of letters and even letter parts. Try to keep the spaces between words proportional to the size of your letters and use your critical eye to make adjustments that will result in spacing that is visually pleasing.

Remember, flourishing an entire word or phrase is all about cohesiveness and balance. All the embellishments need to work together to create an overall effect, and they need to feel natural and unforced. A design need not be symmetrical. Rather, each flourish should be thoughtfully considered, with an eye for balance and unity throughout the entire word or phrase.

In the first example of the word "joyful," the large flourish on the lowercase j results in a visual heaviness on the left side of the word. It can be counter-balanced with the addition of a flourished element on the right. Even though the piece is not symmetrical, it is balanced.

In the second example, you'll see two very different types of embellishments used. Revising this design to make the decorative additions more unified would be a good design choice. For example, adding a petal terminal to the flourish on the ascender of the f would unify all the terminal curves of the flourishes. Additionally, the descending flourish on the bottom right could be replaced by one that is rounder in shape, thereby echoing the rounded flourishes on the f and the j. These seemingly small tweaks have a large impact.

The last example is a piece that has been over-flourished. There are 10 swirly flourishes, 15 teardrop ornaments, and 8 petal terminals attached to one fairly short word! Though there is some unity and repetition in the flourishes that have been used, the amount of flourishing is overkill. Have you heard the turn of phrase about the clothes wearing the person rather than the person wearing the clothes? In this case, the flourishes are wearing the word, not the other way around. As always, be judicious in your use of flourishes and embellishments. I'll say it over and over again: Less is more!

Putting It All Together to Write and Flourish a Single Word

As you can see, there's a lot to think about, even when flourishing a single word! The best way to make sense of it all is to put it into practice. I recommend drafting in pencil and keeping your eraser handy.

Now, let's walk through the entire process from start to finish.

- Write your word or phrase as you normally would in pencil, without adding any flourishes. Examine the word, looking for obvious spots to add a flourish.

 TIP: The remaining steps can really be done in any order. If you know you want to showcase a flourish in one particular part of the word, start there. Then, add the rest of the flourishes, with an eye for keeping them consistent in style.

- If the word is going to be capitalized, consider using a flourished capital. If needed, erase and re-draw the first letter, or simply add to what you have on the page. Stuck for ideas? Review the section on flourished capitals or turn to your Personal Flourish Gallery for inspiration.

- Consider flourishing the exit stroke of the last letter in the word, if it feels like a good fit for the design. Think about how this flourish speaks to the flourishes in the capital letter. Try to choose a style that is cohesive with the first flourish. You may choose not to add a flourish here, or to wait until the end to see if it is needed.

- Do you have any letters with ascending stem loops? Erase the loop and add a variation. Review the section on lowercase letters for ideas or look at your Personal Flourish Gallery.

- Does your word feature a descending stem loop? Erase the loop and add a variation. You might consider an underline flourish, or connect the letter to one of the standalone flourishes you learned early in the book. Check your Personal Flourish Gallery for ideas as well.

- Look for opportunities to create a ligature if the letters lend themselves well to this design element. Ligatures are not always used in designs, so don't force it if an opportunity doesn't present itself. Even when there is an easy opportunity for a ligature, it may not be the best design choice for the composition as a whole.

- Consider adding a standalone flourish, if the design calls for it. Flip back to page 35 to get some ideas, or use something from your Personal Flourish Gallery.

Fearless Flourishing

- Once again, pause and examine your work with a critical eye. Erase flourishes that feel extraneous or "too much." Revise flourishes that look unnatural. Remember that in flourishing, less is (usually) more! If you are unsure about a flourish choice, remove it from the design or keep making adjustments until it feels right.
- Finally, check your design against the Flourish Design Checklist. If any part of your design is not in line with these principles, continue editing or repeat the above process.

In this example, I wrote the word "joyful" as I normally would, then rewrote it without the ascending and descending stem loops. This left room for me to play with flourished variations.

When I use this drafting strategy, I often end up writing the word many times (or I erase a lot!) until I come up with a balanced and cohesive design. As eager as I am to start working in ink, using pencil through this process always results in much better work overall. The more familiar this process becomes to you, the quicker it will go. You will become more adept at flourishing words and eventually find yourself gravitating intuitively to particular design choices. Once I am happy with the draft, then I can move on to the good copy (more on that later). For now, practice flourishing some words and phrases on your practice paper. You can trace over or make copies of the dot grids on pages 126 and 127.

TIP: When I first started flourishing, I was tempted to start writing a word and spontaneously add flourishes as I wrote. I often worked in ink and skipped the pencil stage altogether. This resulted in mismatched, unbalanced designs, and I found myself becoming increasingly annoyed as I wrote and rewrote a design many times. Very rarely did I create something I liked in one try. Eventually I realized that drafting in pencil would set me up for success, saving me time and frustration. I can't recommend pencil drafting enough; it is one of the best tips I can pass along to you as you continue your study of the flourish.

A Note about Other Lettering Styles

Throughout this text, we've focused on the art of flourishing brush script styles in the vein of modern calligraphy. Most brush-letterers do not stick to only script, but often incorporate a variety of print and other forms of hand-lettering. While the tips and tricks listed here specifically pertain to brush script lettering, many of these techniques transfer nicely to print styles and other hand-lettering forms.

The best way to determine if a flourishing style will work with a non-script alphabet is to try it! Begin by writing a few key letters and look for ways to make use of the techniques you've learned here. Consider the print letter M. It doesn't have an entrance stroke or exit stroke, but it does have a curvy stroke that might lend itself to a flourish.

Experimentation coupled with your critical eye will help you determine what works and what doesn't when flourishing other styles of lettering. As always, our Flourishing Design Checklist applies here as well. Let's review it specifically in relation to flourishing non-script styles:

Strive for that effortless flow. Non-script styles may not lend themselves to the organic, flowy shapes of a flourish. If the flourish looks forced or unnatural, it's not a good fit.

Find the balance. Both with individual letters and with full compositions, keep your critical eye focused on balancing the visual weight of all the elements.

Keep it legible. Because flourishes are less expected on non-script forms, it's extra important to check that your lettering is still readable.

Maintain the tension between thick and thin. Non-script styles are often monoline. In this case, keep the flourishes thin, with no contrast. If the lettering style isn't monoline, then this design principle still applies.

Utilize leading lines. This principle of design is applicable to all compositions, regardless of lettering style.

Remember, less is more. I'll say it again and again. Be judicious.

Pick your spots. Use the same technique to find opportunities for flourishing. If a particular non-script style does not afford many openings for a flourish, it's perhaps best left alone.

Of course, all the ornamental and illustrative design elements in this section could be successfully used with any style of lettering. Often the more highly embellished ornaments complement simpler text styles, and vice versa.

Beyond Letters
Numbers, Punctuation, and Special Characters

Numbers

Numbers often get overlooked in favor of letters and words, but it's important to practice writing them because they come up more than you think! Envelope writing, for example, is all about the numbers, and flourishing them well will lead to some very eye-catching designs. If you find yourself using your lettering to create party or wedding invitations or even simply to write the date, you'll need to think about how to flourish them well.

In modern lettering, numbers extend from the baseline to the cap height and have roughly the same visual weight as a capital letter. As much as possible, numerals should look like they belong with the letters near them. In a design that features a highly ornamented style for the lettering, consider ways you might incorporate that same style with your numbers. However, note that

numbers tend to be spaced closely with other characters, so there may not be a lot of opportunity for flourishing. As I've said a few times already, less is often more, and this is particularly true in the case of numerals.

By now you have a comprehensive tool kit of flourishing strategies at your disposal. Writing numbers is a great opportunity to try them out. A number 0 or 2 might have an oversize loop or curl at the top. A number 3 might feature an extra loop between the two large curls. The end of a figure 8 might extend up into a simple flourish or even into a ligature by combining with another character.

Let's try a number 5. First, write it as you usually would. Now, write it a second time, exaggerating the size of the curve at the bottom. Write it a third time, with a curvy cross stroke at the top and an extra curl at the bottom.

Here are some other strategies for flourishing numbers:

- Add a loop or curl.
- Exaggerate a curve.
- Extend the top of the number above the cap height or the bottom of the number below the baseline.
- Add a gentle curve to the stem or to a horizontal stroke.
- Lengthen a stroke to the far left or far right of the number.
- Add a stylized terminal.
- Look for opportunities to create ligatures with other numbers or letters.

When it comes time to use numbers in a design draft, be mindful of spacing. There's no strict rule about flourishing numerals. You'll have to eyeball it often and trust your instincts. If your numbers seem crowded or smooshed together, it'll be best to simplify and leave a little more space in your design. Use your practice paper to give the numbers a try! You can trace over the dot grid on pages 126 and 127.

Punctuation

No matter how wonderful your lettering is, without punctuation, your work will at best be difficult to decipher, and at worst, entirely illegible. As a lettering artist, you need to consider these essential marks in order to create a successful piece.

In hand-lettering, good punctuation is seamless and almost invisible. For that reason, many punctuation marks—commas, periods, colons, semi-colons, quotation marks—are better left alone. These small marks would be obscured by flourishing and would lose their meaning. That said, there are times where more ornamental punctuation marks might be just the thing your design needs! Exclamation marks and question marks can be flourished quite successfully by adding loops, curves, and exaggerated strokes. For most everything else, follow the rule of thick downstrokes and thin upstrokes, or write in monoline. Strive for overall cohesiveness, but keep it simple otherwise.

Use your practice paper to try your hand at some punctuation marks!

Fearless Flourishing

Ampersands

Much beloved (and sometimes maligned!) by hand-lettering artists, the ampersand can add a graphic punch to any design. An ampersand is a ligature of the letters E and T, from the Latin word, "et," which means "and." When it came time to choose a name for my small business, I knew I had to have an ampersand in there somewhere, which is partly how Feist & Flourish Modern Calligraphy was named! I love the way an ampersand can change the entire look and feel of a piece. They can be chunky and bold, delicate and whimsical, elegant or funky. What's more, ampersands are end-lessly variable. There are so many unique ways to create and flourish them!

Here are some ideas to get you started:

- Exaggerate different parts or lengthen strokes.
- Add a curl or loop.
- Extend or exaggerate the entrance stoke or exit stroke of the ampersand.
- Lengthen the exit stroke above the cap height or below the baseline.
- Create a stroke that wraps around the top or bottom of the ampersand.
- Look for opportunities to connect it to another letter and form a secondary ligature.
- Find places to add a simple flourish to the end of the ligature.

Have fun experimenting with flourished ampersands on your practice paper, and transfer your favorites to the Personal Flourish Gallery at the end of the book or in a separate notebook!

In the Spirit of Flourishing

From Ornaments to Illustrations and Other Design Elements

With a background in painting and drawing, it's always felt natural for me to add illustrative elements to my lettering. While most of the decorative components in this section are not technically considered flourishes, their ornamental nature means they certainly fit with the *spirit* of flourishing. From petals and arrows to banners, borders, and botanicals, these illustrative elements will add panache to your designs!

It's tempting to add extra ornamentation once the lettering part of your design is complete, but illustrative elements should rarely be an afterthought. Rather, they should be an integral part of the design that has been thoughtfully considered during the drafting process.

When it comes time to lay out these ornamental design elements, be sure to leave lots of space for your letters, so as not to impede legibility. As always, use these elements wisely; your lettering should always be the star of the show! Well-executed illustrative elements will support the meaning of the lettering, not compete with it.

If you're not sure whether to include an ornament in your design, the Flourish Design Checklist absolutely applies:

- Strive for that effortless flow.
- Find the balance.

- Keep it legible.
- Maintain contrast.
- Utilize leading lines.
- Remember, less is more.
- Pick your spots.

Stylized Terminals

Terminals are the end of a stroke in a letter or flourish. Most of the time, the terminals will be simple, with no embellishment. However, sometimes you may want to add a stylized terminal, such as a ball or petal terminal. These small shapes at the terminals of letters can be used to considerable effect in a design. Feel free to use them whenever you think it is called for in a composition. However, if you use a stylized terminal, be sure to repeat it throughout the entire word or flourish, if not the entire design. You may also choose to use these terminal embellishments on only select words or phrases in a design, particularly when you are mixing different lettering styles. They can add a great deal of elegance, uniqueness, and complexity to a composition.

You might be tempted to make these details all the same size, but stylized terminals are often varying sizes, even within a word. This is because the size of each letter or flourish will call for a different size terminal. Decorative terminals may appear bigger on uppercase letters, for example, and smaller on lowercase letters. Rather than worrying about keeping them the same size, keep these elements proportional to each individual letter's size. Regardless, the shape and application should be similar, and all the terminal details should look as if they belong together. Keep using your critical eye, adjusting the sizing of the terminals as you draft your lettering. This should result in a balanced design, even if the terminals are of different sizes.

It's also probably better not to mix styles unless you are going for a very funky or kitschy look. If in doubt, refer back to our Flourish Design Checklist—simple is usually best! Stylized terminals can also be added to standalone flourishes. You might choose to use these when your lettering is simpler in style, to provide contrast, or when you have featured petal or ball terminals in the lettering and want to add rhythm and unity to a piece.

Petal Terminal. At the end of a stroke, create a small petal shape. The side attached to the stroke will be slightly pointed, while the farther end of the terminal will be rounded.

Ball Terminal. At the end of a stroke, create a small, round ball. Easy!

Small S-curve Terminal. At the end of a stroke, create a small s-curve. You may decide to add more visual weight, creating a very robust s-curve for a dramatic effect.

Small Curl Terminal. At the end of a stroke, add a small curl or hook. Make sure most or all of the stroke ends repeat this element so it does not obscure the lettering.

Illustrative or Whimsical Terminal. At the end of a stroke, add a small illustrative element, resulting in a whimsical look. As always, keep it simple! Make sure these stylistic elements do not impede legibility or look forced and unnatural.

Fearless Flourishing

Serifs. A serif is a short line at the end of a stroke. Technically, serifs do not belong in this section, because they are not actually terminals. In the world of typography, a terminal is the end of a stroke that does not a have a serif. But for our purposes, they operate in the same way: as a stylized design element at the end of a stroke. Play around with different weights and sizes to achieve different effects.

Try attaching stylized terminals to a few letters or standalone flourishes on your practice paper. You can trace over or make copies of the dot grids on pages 126 and 127. As you experiment, you may find other shapes that appeal to your aesthetic, such as arrows or geometric ornaments. When you discover ornaments you like, don't forget to transfer them over to your Personal Flourish Gallery!

Filigrees and Dividers

A filigree is a small standalone flourish, often created in monoline, that adds decoration around your lettering. Dividers are smaller bits of linework that function in much the same way as a frame, just on a smaller scale. In addition to helping to fill negative space, filigrees and dividers can be used to break up a piece and lead the eye to key sections of the design. Generally, filigrees and dividers are visually light, which can be achieved by using hairline strokes. They also often feature decorative terminals.

Filigrees and dividers are not mutually exclusive, as filigrees can function as dividing elements in a composition. What's more, filigrees can be used in a variety of shapes and formats. In the following example, I've shown many variations of filigrees that form a frame or border around the edge of a piece.

Borders and Frames

Decorative borders and frames are another set of tools for ornamenting and framing your lettering. Borders are decorative linework or other ornamentation that go all the way around the outside edge of a design. When they are used in smaller spaces inside a design to provide structure for key words or phrases, they are referred to as a frame. Frames are an excellent way to signal to the viewer which parts of the design are most important and to help create a sense of hierarchy in a design.

Borders and frames provide lots of opportunity for flourishing. Since they do not involve letters, you can flourish them to your heart's delight without concern for legibility. That said, the "less is more" rule can apply here as well. Overly flourished borders and frames could potentially detract from the overall design by taking attention away from the lettering itself. These design elements should always augment your lettering, not compete with it in any way. If in doubt, leave it out!

Fearless Flourishing

Borders and frames should not be an afterthought. Rather, they should be an integral part of the design. Because a border runs the entire outside edge of a piece, I will often design it first. This gives me a better idea of the space I have available to fill with lettering. Depending on the size of a frame, I might start with the lettering or the frame. This entire process works best in a pencil draft, allowing you to make multiple adjustments until everything is just right!

Negative Space Designs

You'll recall from the Essential Terminology section on page 16 that negative space is the space within and around a letter, flourish, or illustration, stretching to the edge of the page or canvas. It's sometimes referred to as "white space." Positive space refers to the letters, flourishes, or illustrations that are the focus of the work or are the darkened/inked part of the work. Positive and negative space can be used in striking ways to create unique and interesting designs.

Functioning in a similar way to frames, simple shapes can be used to contain a single word (or multiple small words), often making use of negative space for the lettering. In this example, the word "in" has been placed in a small oval. The word is created in negative space, by being left white, while the positive space is the dark, inky oval.

The size of the word itself (including the oval) is significantly smaller than the other words in the design, but visual weight is still given to the word because it is darker. This strategy can be used to balance out other large design elements, such as large flourishes. The darkened shape will always be visually heavy, so be sure to balance it with other design elements through size, color, or ornamentation.

> **TIP:** You could also use this technique to highlight more illustrative design elements, such as arrows or even flourishes themselves, making use of negative space to give them more visual weight.

We've talked about using negative space with only one (or a select few) of the words in a design. Of course, an entire piece could be created using negative space. In this strategy, you would contain your entire design within a shape, with the shape being inked or painted in as the positive space. In this example, the word "yum" (and a flourish) have been encased in a coffee cup.

Lettering Inside of Flourishes

Sometimes lettering can be created directly inside a flourish. Consider the descending flourish of the letter r in the phrase, "Lovers gonna love." By turning it into an extra-wide swash, there is room to put a second word inside.

In this example, the positive and negative space has been reversed—the positive space is the darkened area of the flourish, while the negative space forms the shape of the letters.

Fearless Flourishing

Parallel Flourishes

As you look for opportunities to embellish your lettering, consider creating sets of flourishes that are parallel to one another. In this example, the flourish off the descender of the uppercase Y and the cross stroke of the lowercase t can easily be made to be parallel. This repeated s-curve shape is pleasing to the eye, and adds rhythm and movement to the piece. The two flourishes also act as a frame for the word "are." Not every design will lend itself to this technique, but it's one to keep in mind when the opportunity presents itself.

Arrows

Arrows are a fun and funky design element that fill negative space, functioning as leading lines to direct the viewer's eye. While you might not use them in classical or highly elegant designs, arrows work well with contemporary lettering styles. Consider adding arrows when they illustrate the meaning of the text, as in the phrase, "look up." Because the phrase references a specific direction—up—the arrow would also point upward. You might also consider using arrows to point at and highlight key words in a phrase, as in the example here. The arrow flourish begins as the cross stroke of the t but points at the word "simple," drawing the reader's eye toward the key word in the phrase. What's more, arrows can even be filled with lettering, as with the negative space shape designs we noted earlier, making them a very useful tool in your lettering tool kit.

Banners

Banners function similarly to borders and dividers. Filled with your lettering, these decorative design elements help create structure and hierarchy, drawing the viewer's eye toward key phrases or words. They also look cool and will add a wow factor to your work!

Basic Banner

The simplest and easiest to create, this banner will look striking in any design. Make it long or wide to accommodate lots of lettering, or very short to fit just one word.

1. Draw two horizontal lines of equal length, one slightly above your lettering and one slightly below it. Remember to leave lots of room for the letters to breathe. If you're not sure how big to make this shape, try lightly roughing in your lettering first.

2. Draw two dots halfway between these lines, one at each end, where you would like the ends to point inward.

3. Make an inverted triangle shape at each end, with the apex of the triangle lining up with the dots. Use straight lines or curvy lines to achieve different effects. This will create the ends of the banner.

4. Now, create your lettering inside the banner!

Straight Folded Banner

Folded banners with shading add dimension to a piece and help frame your lettering. It's easy for these banners to get a little wonky-looking, so spend time studying how their folds work. I use a piece of paper or ribbon as a guide, playing around with different folds until I like the look, and then copy the shapes. Pay close attention to shading the light and dark areas. You could fill in the dark areas with ink, or use cross-hatching or small dots to create detail. Remember to draft lightly in pencil, and don't be afraid to erase until you get it just right!

1. Create a rectangle slightly larger than your lettering. Remember to leave lots of room for the letters to breathe. If you're not sure how big to make the rectangle, try lightly roughing in your lettering first.

2. Draw four horizontal lines approximately 25% lower in height than the horizontal lines of the first rectangle.

3. Draw two dots halfway between these lines, one at each end, where you would like each end to point inward.

4. Make an inverted triangle shape at each end, with the apex of the triangle lining up with the dots. Use straight lines or curvy lines to achieve different effects. This will create the ends of the banner.

5. Draw short vertical lines to connect the center rectangle to the banner ends.

6. Draw short diagonal lines to connect the bottom corner of the banner ends to the bottom corners of the rectangle, and shade in the folded parts of the banner.

7. Now, create your lettering inside the banner!

TIP: Experiment with adding extra folds to create banners of different lengths.

Fearless Flourishing

Curvy Folded Banner

Curvy banners add a playful touch and a sense of movement to your designs.

1. Draw two parallel s-curves on a slight diagonal slant. The space between them should be wide enough to fit your lettering. Leave lots of room for the letters to breathe. If you're not sure how big to make this shape, try lightly roughing in your lettering first.

2. Close the ends off, creating an s-curved rectangle.

3. Create a petal shape at the bottom left and the top right of the s-curved rectangle.

4. Create the banner ends, attaching them opposite the petal on each side. Make an inverted triangle shape that is either straight or curvy, as desired. Shade in the petals.

5. Now, create your lettering inside the banner. The curve of the banner will determine the baseline of your lettering.

Arched Folded Banner

Use a gentle arch to give a more organic and fluid look to your banner.

1. Create two arches roughly larger than your lettering. Remember to leave lots of room for the letters to breathe. If you're not sure how big to make this shape, try lightly roughing in your lettering first.

2. Close the open ends to create a curved rectangle. You may decide to round the corners slightly.

3. Draw two curvy lines that snake diagonally from the top left and bottom right corners.

4. Draw vertical lines creating the folds of the banner. Then, draw horizontal lines to connect these vertical lines back to the central curved rectangle.

5. Add the ends of the banner.

6. Shade the folded parts of the banner.

7. Now, create your lettering inside the banner. The curve of the banner will determine the baseline of the lettering.

Fearless Flourishing

Bunting Banner

Bunting or flag banners add a whimsical and festive touch for children's rooms, greeting cards, and party décor.

1. Create a gently curving line. You may bring it to the edges of the paper, or have it free-floating on the page.

2. Draw a series of upside-down triangle shapes at regular intervals along the curved line. Be sure they are big enough to fit each letter of your design, and space them so you have enough to complete the full word. Remember to leave lots of room for the letters to breathe. If you're not sure how big

to make the triangular shapes, try lightly roughing in your lettering first.

3. Now, create your lettering inside the banner! One letter per flag is a good rule of thumb.

There are no set rules for mixing banners with other lettering but here are some stylistic considerations to keep in mind. First, a banner will highlight whatever lettering is within its confines. Banners are visually weighty, so whatever lettering appears inside a banner will often become the focal point. Using a banner to frame key words is often best practice. That said, very small, simple banners can sometimes be used with less important words, such as "and" or "to," to create balance in a design by offsetting other large design components.

Second, the curve of the banner will determine the baseline of the lettering. Keep this in mind when drafting the banner. If it's too curvy, it might become difficult to keep the letters from looking wonky. A gentle curve will make it easier to navigate the angles of the lettering. Use a critical eye. While the baseline may vary, the letters should still feel vertically straight, with a sense of gravity holding them to the baseline.

Third, banners often work well when more than one lettering style is used. If the rest of your design is created with calligraphy or brush script, consider using a print style in the banner. Keep playing with different layouts and study others' compositions. Over time, you will develop an intuitive sense for incorporating these illustrative design elements.

Stars and Hearts

Stars and hearts come off a little cutesy, so they are best limited to specific applications where they add significantly to the message or meaning of the piece. Galaxy lettering is certainly a time when stars are called for; these starry details could be within the letters themselves or clustered around the lettering for a framing effect. When creating starry effects, start with dots and vary their placement and size. Stars that are too evenly spaced will look like polka-dots, so make them look random in their placement. Adding a smattering of star shapes in various sizes will add to the effect and make it clear that it's a starry sky. If you are writing on a dark background, a white or metallic paint pen will create a shiny, sparkly effect. If you are using a paintbrush and white or metallic paint, you can flick the paint to create a spatter effect that mimics the look of stars as well.

I like to add hearts in unexpected places, but only when it is called for in the design. For example, transforming the ascending stem loop of the lowercase h in the quote "have a heart" is a subtle way to incorporate a heart and makes sense because it illustrates the meaning of the word itself. Lettering for children's projects, such as for nursery décor, is a very fitting place to add a heart or two. Using a large heart as a border or frame, with the lettering in either the positive or negative space, can also be very effective.

Fearless Flourishing

Lines and Dots

Don't underestimate the power of small marks on a page. Lines and dots of different sizes can be used to great effect. Try using short lines to create rays emanating from your lettering. These add a sense of excitement and will act as leading lines, framing your lettering and drawing the viewer's eye to the focal point. Dots can be used for a pointillism effect. Consider the phrase, "salt of the earth." Using dots to create the look of salt both illustrates the meaning and frames the lettering in a pleasing way!

As with any illustrative element, lines and dots can be overused and distract from the lettering itself. If they obscure the letters in any way or detract from the message, don't use them. Experiment with different styles and transfer your favorites to the Personal Flourish Gallery!

Highlights and Shadows

Use an opaque white or shiny metallic to create the look of highlights *on top of* your letters (I like to use a white Gelly Roll pen, Molotow Liquid Chrome marker with a thin tip, or thin Sharpie paint pens for these details). Letter a word, then imagine it is being illuminated by a

light source. The highlight would appear in the same spot on every letter. I like to highlight the top to middle of downstrokes across the entirety of a word.

Use any light tone marker to create the look of shadows *beside* your letters. If my lettering is done with black ink, I like to use light gray ink for the shadows (the Tombow Fudenosuke Twin Tip marker is great for this). If my lettering is in color, a lighter tone in the same color family can be very effective. Letter a word, then imagine it is being illuminated by a light source. The shadow will fall in the same spot on every letter. I often place shadows on the right side of every downstroke. You can certainly experiment with placing shadows to the right of upstrokes, but it's not a necessity and can affect the delicate feel of the hairlines. What's more, the shadows you create can touch the letter itself or be slightly offset, leaving a space between the letter and the shadow. Experiment with shadows of different thicknesses to achieve different effects.

Interior Letter Details

Interior letter details are really just doodles *on top of* your letterforms to add interest. Once again, an opaque white or metallic ink or paint marker will work well on dark ink lettering. Lettering done in lighter tones can be overlaid with darker colors or black ink. You could also draw these details in at the drafting stage, so that the interior details do not

Fearless Flourishing

need to be drawn over the top (rather, the white of the paper will show through the areas you do not ink).

Interior letter details are most often added to the downstrokes only, so they don't interfere with the lightness and legibility of the upstrokes. Some details to try include:

- Regularly spaced dots, or irregularly spaced dots that give an ombre effect.
- Decorative shapes like diamonds, triangles, or other geometrics.
- Filigrees or other organic shapes.
- Horizontal or vertical striping.
- Hearts, stars, or other doodles that augment the meaning of the word.
- Shading that adds a three-dimensional effect to the letters.

Other than following the principles of the Flourish Design Checklist (page 20), there's no right or wrong way to play with interior letter details, so have fun experimenting with variations. Then, add your favorites to your Personal Flourish Gallery so you can refer to them later!

Botanical Elements

Anyone who has looked at my lettering work will quickly deduce that I love a good floral. Botanical line drawings make up a lot of my illustrative work, and I've never met a leafy garland I didn't like! Botanical elements are a lovely way to fill negative space, and are particularly organic and feminine in nature.

One of the best ways to learn to draw botanical elements is to study real-life examples from nature. I often pull samples from my garden to sketch, and whenever I travel to a new region, I try to find a new plant variety to study. Not to mention, drawing from life is a great excuse to fill your art space with flowers!

Botany field guides are another useful source to draw from, and of course, you can always google the specimen you would like to illustrate. Resist the urge to copy someone else's photograph or line drawing exactly. Instead, use these images as inspiration only, and try to draw from life as much as you can.

The Earth Laughs in Flowers

RALPH WALDO EMERSON

Nature is never perfectly symmetrical or lacking defects. Look at any leaf and you will see folds, pits, tears, holes, and discolorations. To achieve a more organic and realistic effect, embrace asymmetrical details and imperfect lines. If you are going for more of a cute or clean illustrated effect, make your botanical elements symmetrical and use clean lines and curves. If drawing from life does not come naturally to you (and it doesn't to all of us), you can follow along with my step-by-step guide for some simple and basic botanical shapes below.

I prefer to create these illustrations in monoline, without contrast between thick and thin, so I do not use a brush pen. That said, some contrast may be preferable to you (I sometimes outline botanical line drawings with a thicker line), so feel free to use whatever tool helps you achieve the aesthetic you prefer.

Simple Leaf

Leaves are easy to draw and can be layered over and around each other for a lovely effect. To draw a simple leaf, follow these steps:

1. Draw a curved line.

2. Create a mirror image of the first curved line that connects with a point at either end.

3. Draw a line down the center, from point to point.

4. If you'd like to add further detail, draw veins from the outer edge to the center line. These can be symmetrical and meet in the middle, or they can be staggered. Any time the details are less symmetrical, the leaf will look more organic and true to life. Symmetrical details will appear less realistic and more simplistic or cartoon-like.

5. If desired, add a stem to one end.

Long Skinny Leaf

Varying the shapes and sizes of the leaves in a design can result in a very pleasing effect. These long and skinny leaves are the perfect foil to the simple leaves you just learned.

1. Create a long, slightly curved line.

3. Draw a long line up the center of the leaf. You might experiment with having this line connect only at one end of the leaf. If you'd like, add a fold to the leaf by adding a smaller curved line on one side of the leaf.

2. Create the mirror image of the first line, and have them connect at each end in a point. If one end of the leaf is going off the page, that end does not need to connect.

4. If desired, add a stem to one end.

Leafy Branch

Leafy branches are my go-to botanical illustration, as they can be endlessly varied. These branches can be long or short, and can be curved around letters. The leaves can vary in their shape, size, placement, and level of detail. They look just as good on their own as they do when repeated throughout a design.

1. Draw a slightly curved line. This is the stem.

2. Add a simple leaf at the very top.

Fearless Flourishing

3. Add matching leaves to each side of the stem. They can meet symmetrically at the middle, or stagger in their placement. For a more organic look, skip a leaf occasionally, or layer a second one for fullness in some areas. Leave some room at the bottom for the stem.

4. If desired, add a few extra layers of leaves along the branch.

5. Add whatever details you desire: a line down the center of each leaf, veining leading to the outer edges, or shading at the ends of each leaf. You might also choose to completely fill in the leaf. If you desire, thicken the bottom of the stem.

6. Consider adding branches off the first branch for a fuller effect. Follow the previous steps to fill in the second branch.

Experiment with various leaf shapes and try different details. The leaves could be rounded or pointed, large or small, symmetrical in placement or asymmetrical. When you find a style you like, add it to your Personal Flourish Gallery at the back of the book or in a separate notebook!

Fern

Ferns add a swirly, organic element to your compositions. They also pair well with the other leaf types covered above.

1. Create a curvy line with a curl at the end.

2. Start at the bottom and create long, skinny leaves with pointed ends that attach at the stem. These leaves should meet in the middle with symmetry. As you continue adding long, skinny leaves, decrease the length and width of each one, resulting

in the leaves becoming smaller as you continue up the stem. At the curl, the leaves should be very small and pointy, almost like little leaf buds.

3. Draw a line down the center of each leaf.

4. If desired, thicken the bottom of the stem. Add a jagged edge around each leaf, if desired.

5. Consider adding branches off the first branch for a fuller effect. Follow the above steps to fill in the second branch.

Wispy Branch

These monoline branches can add a delicate touch to your designs, and are a good filler in a mixed botanical design, such as a wreath.

1. Draw a gently curving line.

2. Leaving room for a bit of stem, start at the bottom of the branch, creating short lines that point upward on a slight diagonal slant. These lines can be symmetrically or asymmetrically placed, straight or curved. You may consider skipping or overlapping some lines for a more organic look. As you move up the branch, make the lines progressively shorter.

Fearless Flourishing

3. Consider adding branches off the first branch for a fuller effect. Follow the previous steps to fill in the second branch.

Open Flower

This open flower with organically shaped petals and the closed flower with pointed petals on page 104 are loosely based on real-life plants, focusing on basic shapes that evoke the idea of the flower. If you'd like to draw more realistic versions or try other varieties, try drawing from life or botanical field guides.

1. Draw a rough oval shape with bumpy edges. Fill it in with ink.

2. Draw a row of petals around the oval shape, giving each petal an irregular shape.

3. Add a few more rows of petals behind the first ones.

4. Add short lines at the edges of the petals, especially where there are dips in the petal edge. Add leaves or a stem at the bottom, as desired.

Closed Flower

1. Draw an almond-shaped petal, then add a second one that is touching the first.

2. Add two or three petals, also touching the first. Some will look as if they are tucked behind the first petals. All the petals should be pointing in roughly the same direction.

3. Add a few more petals behind and between the first row of petals. Add lines inside each petal, from the bottom upward, with more lines closer to the bottom to result in a shaded effect.

4. Add leaves or a stem at the bottom, as desired.

Buds

Varying the size and shape of your flowers will add visual interest to your design. Buds often look good in pairs or small groups, with each being a different size. They may stand alone or be attached to larger flowers. For variation in your design, experiment with having some buds closed and some beginning to open.

1. Create two parallel curved lines.

2. At the top of each line, add a rounded heart shape. Don't give the heart shape

Fearless Flourishing

hard corners, opting instead to round them out.

3. Above the dip of each heart shape, create a small arch and fill it in with ink.

4. Draw a line from the bottom of the rounded heart shape to the dip at the top, to imply petals not yet opened.

5. Add more petals and add leaves to the stem as desired.

Berries

Berries can be a simple cluster and can also look lovely when attached to a longer stem.

1. Create a slightly curving line. This is the stem.

2. Add a small teardrop shape to the top of the line. This is a berry.

3. Add more branches with berries, as desired.

4. Draw a few shorter branches that do not have berries, as desired.

TIP: Sometimes a small circle on the end of a short, curved line is all that is needed! Don't be afraid to simplify these elements in the service of your design.

Wreath

Botanical wreaths are an attractive way to frame your lettering. Wreaths can be simple, with one kind of foliage or flower, or ornate, with many varieties of leaves and florals. You may create a wreath that is full and wild, with elements layered one on top of another for an over-lapping effect, or you may opt for a sparser look, with no overlapping. Wreaths may take the shape of a fully enclosed circle, or they may have open areas. Feel free to change the shape of your wreath to an oval, square, rectangle, or even a heart.

1. Block out the size of your lettering by lightly penciling it in or creating rectangles to denote its placement.

2. Sketch the rough size and shape of your wreath. By no means does the shape need to be a perfect circle. Allowing it to be a little wonky will result in a more natural-looking wreath. Use a compass from a simple geometry set to create a circular shape, or trace a round object, such as a bowl. For other shapes, consider printing the shape you need on a home printer and

then tracing it with a light box. Of course, freehand drawing the shape is always an option as well!

3. Fill the wreath with the botanical elements of your choice. Begin with larger pieces, then add smaller ones. I often start at the bottom or top and place the botanicals pointing generally in the same direction, as this creates a sense of movement.

4. Add in smaller elements, such as berries or buds, as desired.

5. Stand back and eyeball the wreath, checking for an even fullness. Fill in sparse areas and add details or shading where appropriate.

Wreaths can be endlessly varied. Experiment with different shapes and styles, and add your lettering for a beautiful finished piece!

Botanical Illustrations as Flourishes

If you really want to use botanicals in a spectacular way, you can attach them to your lettering work. In this way, the botanical illustration acts as a flourish. For example, in the image below, the terminal strokes of the word "luxuriantly" are flourished as leafy branches! Or, try a descending stem loop underline flourish and embellish it with foliage or florals.

Many of the other botanical elements described in this section can also be added directly to letters. Instead of covering the entire letter in botanicals, consider embellishing the entrance and exit strokes, swashes, ligature lines, and flourishes. When doing so, be sure to uphold legibility above ornamentation. Illustrative flourishes are lovely but unhelpful if they obscure the meaning of your lettering.

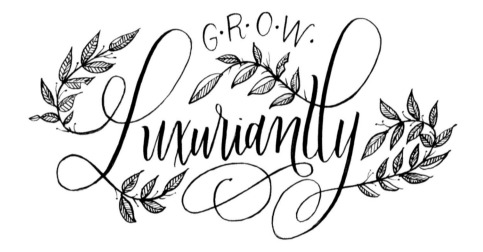

Fearless Flourishing

SEVEN

Flourishing Compositions
From Drafts to Final Copies

Composition Tips, Tricks, and Tools

By now you've got a large selection of flourishing techniques at your disposal. It's time to put them into practice by creating finished compositions. If you're anything like me, you'll probably be tempted to grab the nearest brush pen and paper and start writing in ink, but once again, I recommend starting with your trusty pencil and eraser.

I often mention pencil drafting and erasing because it's such an essential step in creating spectacular flourished works. Taking time for this step will drastically improve the quality of your finished compositions.

And remember, these guidelines are specifically for highly flourished compositions. There are many other strategies for composing hand-lettering in general, but for your purposes, focus on laying out words specifically with the intent to do some significant flourishing.

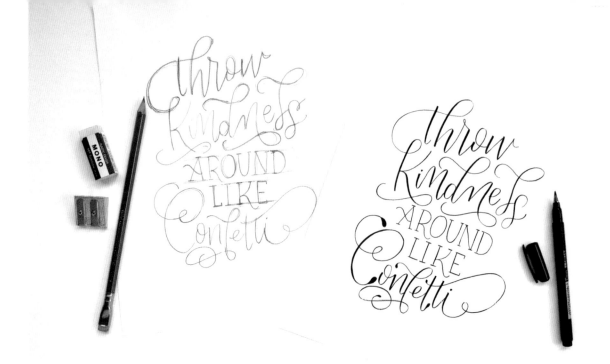

Orientation

One of the first steps in creating a design is determining the orientation of the page and assigning spots to all the words. Once you've chosen portrait or landscape (or square, if that's what suits you), consider how the words might move across the page. Will they be laid out in one horizontal line of text? Will the words be broken over multiple lines in a vertical arrangement? To help you decide, consider which words you might want to highlight.

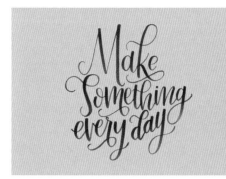

Key Words, Focal Point, and Hierarchy

The viewer's eye should travel through the design and linger on the focal point. Which words or phrases in your text are the most essential? I like to write the text in my regular handwriting and underline the key words or phrases. This step helps me to visualize possible layouts before jumping into a full draft. Once you've done the same and determined the key word(s), it's time to use the principle of hierarchy in the drafting process to make the key words stand out.

In lettering, hierarchy is assigning prominence to some words or letters while giving less emphasis to others. You might use size to achieve hierarchy, making the key words much larger than the others. You might give the key words more visual weight by placing them in a banner, using a frame, or highlighting them with flourishing. You may use a different style of lettering or use color to place emphasis on these more significant words.

Once you've considered the key words, it's time to pencil in the remaining words. Remember, to achieve hierarchy, you'll need to ensure these words are less dominant so as not to detract from the focal point of the piece. That said, they don't have to be plain or boring. You can still play with contrast, combine different styles, and use flourishes throughout your piece; just keep an eye on the positive and negative space. The visual weight of all the elements should be fairly even, with a sense of rhythm and repetition in the design. These elements of design will usually result in harmonious compositions. All of these topics need to be addressed in the drafting step, and I've got three strategies for you to try.

Drafting Strategy One: Thumbnail Sketches

Thumbnail sketches are just that—tiny sketches, drawn quickly, as one tries out several different compositional layouts. Perfect for brainstorming, a thumbnail sketch is the next logical step after determining your key words. You can play with different page orientations, as well as block out a variety of designs, without the pressure of spacing things perfectly and the time commitment of a full draft. Often, seeing three or four thumbnails together on a page will help me confidently decide upon a design direction, and I can follow this strategy up with one of the next drafting strategies as I move toward a full draft.

How to do it? Start by drawing a small square or rectangle to represent your page. You might add some quick guidelines, but thumbnail sketches are hastily drawn, and guidelines are not a necessity. Now, place your key words, then fill in the rest of the words. Add your flourishes and other design elements, then move on to the next thumbnail sketch. This time, try something different, without worrying too much about it being perfect. The whole point is to get a quick idea of what layout you might like the best. Repeat as needed, and you'll find yourself with a little gallery of ideas for your draft!

As a creative exercise, you might try filling an entire dot grid page with thumbnail sketches of the same text. You'll be surprised how many different ideas you can come up with when you put your mind to it!

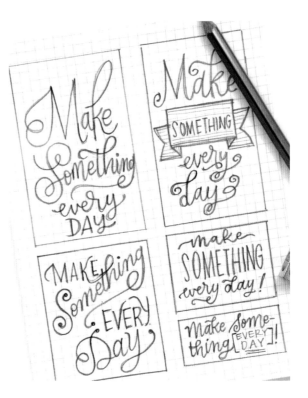

Drafting Strategy Two: Start Simple

With so many options for flourishing a design, it helps to start simple by using the negative space within the text to help guide flourish choices. Negative space might be more difficult to see in a thumbnail sketch, so this strategy is best done on a full-size piece of paper. Remember, negative space is the space within and around a letter, flourish, or other design element, stretching to the edge of the page, sometimes referred to as "white space." These open areas on the page are often obvious places to add flourishes and can help bring balance to a design.

Fearless Flourishing

Choose a phrase you'd like to letter, and write the text in your normal handwriting at the top of the dot grid. Take note of the key words. Again, you may want to underline or circle them to remind yourself when it comes time to draft your design. Decide the orientation of the page and make some initial decisions about how you will place the words on the page, or do a few thumbnail sketches first, if it helps you to visualize the layout.

Now, it's time to start drafting. Begin by writing the entire text in pencil, but *without* any descending stem loops, ascending stem loops, or cross strokes. It looks and feels a bit strange to write this way, but doing so makes the next step much easier. This step is why I call this strategy, "Start Simple." By removing all the ascenders, descenders, and cross strokes, you will simplify your text and get a clear idea of where your negative spaces are.

Take a minute to look at the text on the page. Hold it up, squint your eyes a little, and assess the open areas on the page. Are there any spots really calling out for a flourish? That's probably a great place to start. Use your pencil to draw in whatever flourishes you intuitively feel will fit there. You can always erase and adjust it as the rest of your flourishing decisions are made.

Next, fill in the descending stem loops, ascending stem loops, and cross strokes, with an eye for flourished versions. This is a brainstorming stage, so it's okay to try whatever ideas come to mind. At the end of the drafting process, you can take some time to simplify by editing out whatever is too much. If any of the ascending stem loops, descending stem loops, or cross strokes are causing crowding, consider moving an entire word slightly to the right or left, which will allow a little more space.

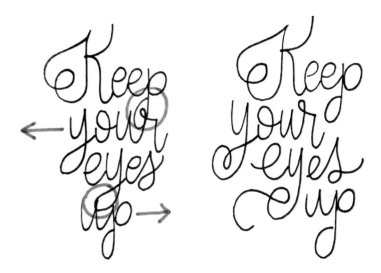

Now, add flourishes to the beginnings or ends of words, and look for opportunities to add a ligature or standalone flourish. Consider whether a frame or border is called for, or whether something more illustrative would add interest to your piece. Draft these ideas into the design.

Continue to revise your design. If any area looks like it has too much visual weight, try simplifying the flourishing. Conversely, areas that have too much white space can be embellished further. Overall, you are looking to create a balanced composition in which the flourishes feel natural and unified. Ask yourself if all the elements look like they belong together. In this drafting phase, you are free to try lots of ideas, erasing as necessary until you find the perfect balance!

Drafting Strategy Three: Build from the Best

Starting simple is great for beginners or when you're not sure about your artistic direction for a piece, but sometimes you'll find yourself with a brilliant flourishing idea right from the get-go. Perhaps your quote speaks to a specific illustrative element, or maybe you've been dying to try out a new banner, frame, or flourish idea.

For this strategy, you'll start with your best idea, then build your design around it. This technique places value on the notion that every flourish should be intentional and a planned element of the design. As we did in the first and second strategies, you'll start by writing the text in your own handwriting and noting the key words. However, this time, every decision you make should be highlighting that design element you've decided to start with. I call this "building from the best."

For example, in this piece, I wanted to work with a heart-shaped ascending stem loop. Normally, I would recommend you use hearts sparingly, as they can come off a little kitschy, but for this quote it just felt right. It's my "best" idea, and I want the entire design to work together to make it the focal point. Because the heart-shaped ascending loop is the focus of the piece, I'm going to highlight it by placing it in the center line (vertically) of the composition, making it larger than the other lettering, and ensuring it gets the most visual weight. All the other words and design decisions will serve to accentuate the heart. Fancy script is reserved for the focal point, while all the other lettering is simpler printing. The flourish below the word "heart" also leads the eye to the focal point.

And, of course, just like you did with the first drafting strategy, you'll want to examine your draft with a critical eye and keep the Flourish Design Checklist in mind. Less is usually more,

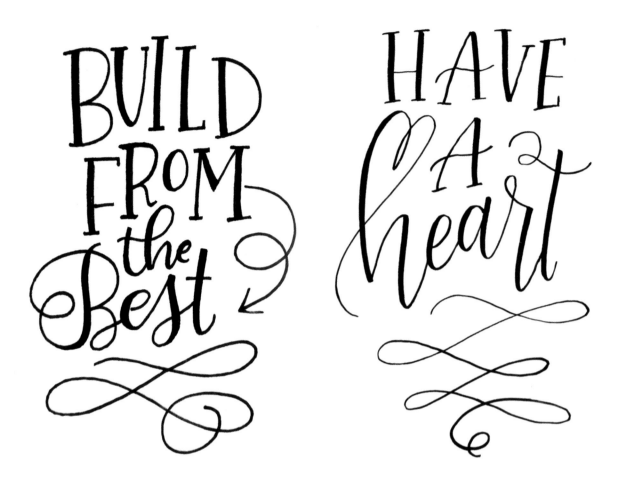

especially when you are building your design around one key design element. Often you will want to keep the rest of your design on the simple side to emphasize that "best idea" you started with!

Multiple Drafts

Regardless of what drafting strategy you use, you might find yourself needing to make multiple drafts. Often my first draft will have numerous pencil lines that have been erased and re-drawn, resulting in a mess! While a messy draft is to be expected (and even welcomed!), creating a fresh copy of it that retains all the best compositional elements will help you feel confident about your design. But how to accurately transfer your design from one page to the next? Enter the light pad.

With a brightly lit surface, light pads (sometimes known as light boxes) allow you to trace the best parts of your draft onto a fresh piece of paper. In the absence of a light pad, simply placing your paper on a window functions in the same way. You can even DIY a light pad alternative by using a clear plastic container with a light source under it. Just make sure the container has a smooth surface and sits flush with your work surface.

I'm a huge fan of light pads for drafting, but tracing paper works in much the same way. When you're ready to transfer the best parts of your draft to a new page, simply slide a piece of tracing paper over the top and keep on drawing. With both tracing paper and light pads, you can put a page of guidelines underneath your draft to help you perfectly size your lettering.

Once you've traced the elements of your draft that you want to keep, you can continue building your composition on the new page until you are happy with your design. Sometimes I do this many times, resulting in many drafts!

Technical Tips for the Drafting Process

Drafting in Monoline

As you draft your work in pencil, don't forget that you are working in monoline. Monoline lettering occurs with writing utensils that do not have a flexible tip, and thus do not create lines with variable weight or thickness. Remember that brush-lettering always has contrast between thick downstrokes and thin upstrokes. If you do not account for this in the 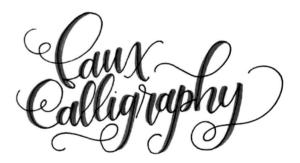 drafting process, you may find that the spacing of your draft will be too tight when it comes time to ink it with a brush pen.

There are two strategies for dealing with this. The first is to simply leave a little more space between the letters, particularly around the downstrokes. However, with this method, it can be a tricky to visualize where the white space is, so I like to shade in the downstrokes with my pencil or pen. This second technique is called "faux calligraphy," and it's often used in applications where only monoline tools are available, such as painting with paint pens or chalk pens. Using this technique may seem like a little extra work, but it only takes a minute or two and will help you get your spacing just right!

Fearless Flourishing

Using Graph Paper and Dot Grid Paper

Both graph and dot grid papers can be very helpful in the drafting process. By counting boxes or dots, you can place various design elements with precision, and of course, the graph and dot grids can also function as guidelines for your lettering.

Drafting Curves and Shapes

Sometimes you may want to incorporate a curve or shape into your design. Apart from thumbnail sketching, which is meant to be done quickly, incorporating these elements is better done in a methodical way. Resist the temptation to freehand draw these shapes, to avoid a wonky layout or a design that feels messy. Rather, make use of tools to help draft perfect curves and shapes.

For curves, I often trace round objects that I have around the house. I keep a selection of vintage glass vessels that I have collected over the years in my art space, and often reach for one when a layout calls for a gentle curve. I also have a collection of vintage drafting tools and find myself reaching for my French curve whenever I am creating an organic layout. Of course, a compass will allow you to create circles of any size and is a great tool for drafting curved guidelines or circles.

Tracing also works well for other shapes, if you can find objects that suit. I have a heart-shaped dish on my art desk that I use often for 5x7-inch cards. You can always draw the shape you need using graph paper or dot grid paper and a ruler. When you've drawn it to size, use a light box or tracing paper to transfer it to your draft.

> TIP: If you find yourself tracing the same shape many times, as in envelope art for wedding invites, you might choose to trace the shape onto cardboard, carefully cut it out, and use it over and over again as a guideline. When addressing envelopes, I suggest creating a master guideline on cardstock that fits inside the envelope. Pop your envelope on your light pad and you will have a perfectly placed template every time!

Mirroring and Duplicating Flourishes

Another use for light boxes and tracing paper is for mirroring and duplicating flourishes and other design elements. Imagine for a moment that you have just painstakingly created an intricate piece of filigree or a lovely, complex flourish, and you'd like to repeat it or create the mirror image of it elsewhere in your design. Rather than attempting to freehand it a second

time (no doubt resulting in an imperfect facsimile), you can use your light box or tracing paper to create a much closer copy.

To duplicate a flourish using a light box:

- Put the flourish on the light box and trace it onto a second piece of paper.
- Put the second piece of paper with the duplicated flourish back underneath your draft page, taking care to place it properly.
- Trace your flourish and perfectly duplicate it!

The same strategy works with tracing paper, but you'll add an extra step:

- Slide a piece of tracing paper over your draft and trace it.
- Lightly color a layer of graphite on the back of the tracing paper under the flourish you just traced.
- Put the piece of tracing paper back over the draft (being careful to place it exactly where you want the flourish to be), and draw over the top of the flourish design. The graphite should transfer to your draft!

Both strategies work for mirroring flourishes as well. In this case, you would simply flip over the paper with the flourish you want to mirror before completing the steps above.

Evaluating Your Draft

Once you've worked through at least one of the drafting strategies, it's time to put the pencil down again. Step back from your piece and consider what is working in the design and what isn't. Ask yourself some questions.

- Have you over-flourished? Try erasing and simplifying.
- Are some flourishes looking a bit unnatural? Erase and draw them again or remove them altogether.
- What parts of the design are particularly successful? Perhaps you should accentuate these parts or simplify other areas so these ones stand out.
- Is there a rhythm to your composition? Do the different flourishes look unified in their design? Make changes so that stylistic elements are repeated, making sure all the flourishes look like they belong together.

- Have any of the flourishes obscured the letters so they are not legible? Revise your design so that each and every letter is easy to read.

TIP: When checking for legibility, ask a friend or family member if they can read it.

- Are the terminals of your flourishes pointing back toward the focal point? If not, erase and re-draw to make use of the principle of leading lines.

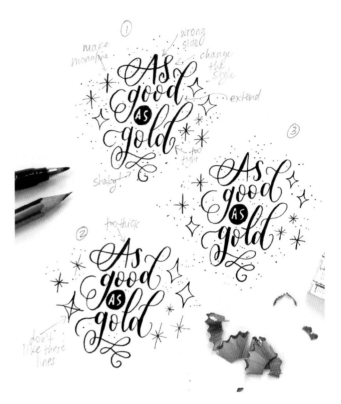

Hopefully, by now these questions feel very familiar. That's because they're the kinds of questions you should always be asking yourself when you are following the Flourish Design Checklist (page 20).

The principles from the checklist should always guide your drafting and composition practice. Whenever I keep these at the forefront of my mind, my flourishing work is infinitely better! Reviewing these principles often is one of the best tips I can give you.

From Drafts to Final Copies

When you are all done drafting and you are happy with your design, it's time to create your final copy. Once again, a light pad will be an invaluable tool, allowing you to see your draft under the final copy page as you trace over it. You might choose to lightly pencil over your design before inking it on the good copy page, but my preference is to directly trace over the design on the light pad in ink with my favorite brush pen (or paintbrush, if it's watercolor lettering). Of course, freehand drawing the design is always a possibility, but after spending all that time on your draft, you can save yourself the trouble of potential mistakes by using the light pad.

Whatever you do, go slow! Brush-lettering and flourishing almost always looks better when it is done with a steady hand at a moderate speed. Resist the urge to plant your wrist on the

table, especially for those sweeping flourishes. You'll need to lift your hand off the page to create those swirls, swoops, and swashes with finesse!

As you create your lettering and flourishes, don't forget that you can lift your pen from time to time and take a break. Remember, script brush-lettering is not created in one continuous line. You might even decide to turn your page to get the steadiest line for certain shapes or flourishes. For example, when I do a cross stroke, I often turn the page 90 degrees, so I can pull the cross stroke toward my body. This almost always results in a cleaner line than when I try to create the cross stroke horizontally.

If you make a mistake, don't panic. First, examine whether the imperfection can be saved. Perhaps you can go back in with the tip of your brush pen or paintbrush and do a little touch-up. If your pen or brush tip skipped on the page, fill the gap in with a little light stroke. If the opposite has happened, and there is too much ink or thickness in an area, you might be able to lift it off by lightly rubbing the page with a sand eraser. However, because a sand eraser will take off the top layer of the paper, this strategy is only suitable for small jobs.

If the mistake is not fixable, you'll have to start again. If one part of your design is giving you trouble, perhaps a shaky ascending stem loop, try isolating that movement and practicing it repeatedly. I like to fill an entire page with the tricky shape. The repetition ensures I lock in the muscle memory before I attempt the good copy a second time. Make sure your practice shape is the same size as you will be creating in your good copy and use the same size nib on your pen or brush. You'll be surprised how much this strategy can help!

If you're finding that your hand is a little shaky, you might find it better to take a break and try again another time. There are multiple factors in hand shakiness, including hand fatigue or sitting too long. For me, it's usually too much (or not enough) coffee! Whatever the reason, taking a break can be helpful after a long drafting session. Come back to the good copy with fresh eyes and a relaxed hand (but don't forget to warm up first!) and you'll find yourself executing those swirly flourishes with ease.

The Lettering Artist's Process

Enjoy the Process

From the first moment I saw flourished lettering, I knew it was only a matter of time before I would do it myself. Although my experience in illustration and painting gave me a bit of

Fearless Flourishing

a head start, I found the art of the flourish still required purposeful study and practice over time. It was not simply an act of acquiring the right tools (indeed, some of my Learn to Letter workshop students have expressed surprise that simply writing with a brush pen did not make them an instant lettering artist!).

I remember the day I was finally able to consistently create an oval. I had been doing full-page drills of ovals for days. Suddenly, something clicked, and that delicate transition from thick to thin became easier. My best advice to you is to do a lot of work, every day, even if it's just a few marks on a page. Do the warm-ups and the drills, repeat the movements over and over, and keep practicing those flourishes. Even when you find yourself achieving competency, it will always be helpful to review the basics. Your craft will always improve with warm-ups and drills. I can't wait for you to have that same moment of delight when you suddenly realize your own competence in creating beautifully flourished work.

Don't forget to look back on prior work and celebrate how far you have come. I highly recommend you keep your first attempts as a reminder of your progress!

Finding Inspiration

Inspiration is one of those nebulous things that can't be manufactured. Throughout my creative journey, my inspiration has ebbed and flowed, but I have found a few ways to nurture it. Allowing myself time to letter and draw in an unstructured and playful way often jumpstarts

my creativity. Doing things that are life-giving, like being outside or playing with my kids, often brings fresh ideas. As a person of faith, I find prayer and scripture spark something new in me. And, of course, having fresh flowers in my workspace or taking a walk in a garden often inspires my floral works.

When it comes to finding ideas for flourishing, simply training your eye to notice typographic details in the world around you will yield new inspiration every day. Signage, packaging, printed materials, and other graphic design artifacts often inform my aesthetic. Once you start looking for it, you'll be amazed how much hand-lettering is used all around you, from shampoo bottles to grocery store signage to the local farmer's market logo! And, of course, Instagram is having a bit of a calligraphy moment. The lettering community there is active, encouraging, and rife with inspiration.

Wherever and however you draw inspiration, be sure to put out work that is uniquely yours. Be inspired by others' work but don't post or publish anything that is derivative. Find inspiration from many, many sources, and keep practicing your own ideas. Soon you will find your own voice and style!

Keeping a Sketchbook

When it comes to lettering and sketchbooks, there are two main camps: those that do and those that don't keep a sketchbook. I will confess that I don't fit neatly into either camp, as I waver back and forth on this notion. While I love to keep a sketchbook for jotting down ideas, I sometimes find the binding constricting when writing and drawing. It's also unwieldy to place on a light box, making multiple drafts more difficult. For this reason, I suggest doing major drafting projects on single pieces of paper. This will give you much more freedom throughout the many steps of the drafting process.

That said, I do like to keep a small sketchbook in my bag, as I often find flourishing inspiration around me throughout my day, and I like to do a quick, on-the-spot study of it so I don't forget. In this way, a sketchbook can serve as another sort of Personal Flourish Gallery! It's also nice to keep your sketches together in one place. I love to look back at old sketchbooks and see how I have progressed in my craft.

When selecting a sketchbook for use with brush pens, don't forget to choose a book with very smooth paper, so as not to fray your pen nibs. If you can find a sketchbook with paper that is smooth and somewhat transparent, you can treat it like tracing paper and do multiple drafts that way.

Keeping a sketchbook is not necessary (and may even impede your drafting process). Whether you keep one is a personal choice for your own practice!

Perfectly Imperfect

I love this turn of phrase. It's so applicable to a study of any craft, but especially to the art of flourishing in lettering. All that drafting, drafting, drafting, and so often I still can't make it perfect!

As with any work done by hand, flourishing is not meant to be perfect. Script brush-lettering and modern calligraphy are the art of writing and drawing letterforms *in the moment*. Flourishes are supposed to look like they were made by hand, *by you*, at a specific time in a specific place. If brush-lettering was meant to be technically perfect, it would have to be done by a machine. Modern calligraphy has become so popular recently because people respond to the handmade quality of work made by real people.

So, embrace the little mistakes and imperfections that are inevitable and celebrate the work you are making, at whatever skill level you find yourself. I highly encourage you to show your work off to friends and family, frame it and hang it on your wall, give it away as gifts, and post it on social media. Keep records of your progress and look back on it often. Be proud of where you are at *right now*. The art of the flourish is a difficult one. Keep practicing the techniques in this book and soon you will find yourself fearlessly flourishing all your lettering pieces!

Developing a Personal Flourishing Style

From lowercase to uppercase and all the special characters, from filigrees to frames to illustrative elements, and from thumbnail sketches to finished pieces, we've covered everything you need to create beautiful, intricate, stunningly flourished pieces of art. You've completed countless practice pages, repeated new movements over and over, and mastered everything from basic strokes to complicated flourishes. By now you have a flourishing toolbox

that is positively brimming with strategies and techniques, not to mention a Personal Flourish Gallery full of your favorite flourishes to draw from as you start to sketch.

All that's left is to watch and see how your own personal flourishing style blooms as you continue to put your newfound skills into practice. The key to developing your own style is to do a lot of work. Just keep making new lettering pieces. Challenge yourself to try new ideas, tools, or styles, but also do what feels good and right to you.

Most of my work is done in black ink on white paper. I've certainly experimented with all the colors (yes, all 96 dual-brush markers offered by Tombow!). I've created artwork with endless new techniques, many different tools, all the "coolest" markers and specialized papers, but I always return to black on white. I've heard other letterers bemoan basic black, but I find it anything but basic. My minimal, mostly monochromatic palette informs my aesthetic, an aesthetic that feels like me in lettered form. And, amazingly, people tell me that they recognize my work without looking at the name attached to it. What a compliment!

I didn't set out to have any particular style. Instead, out of much experimentation, I *relaxed into it.* Resist the urge to conform to lettering trends or to model your flourishing journey after anyone else's. Instead, just keep making. Make something daily if you can (my personal creative mantra is #makesomethingeveryday!). As you grow in your skills, you'll find yourself gravitating to certain stylistic choices, design elements, color palettes, tools, and techniques that feel personal to you. See where your curiosity and inspiration take you. The combination of all those influences will inform your own personal aesthetic. Let it develop naturally over time, and then be true to it.

These sentiments apply to all lettering, but I mean them for your flourishing journey as well. Flourishing is so uniquely personal. As your hand moves across the page, you are making something particularly and utterly yours, in a specific place and time, which no one else can re-create. Of all the ways to make your lettering unique, flourishing stands out in its ability to transform your work in new and exciting ways.

Here's to your creative journey! Use the hashtag #flourishfearlessly to tag your work on social media. I can't wait to see what you make.

Fearless Flourishing

Personal Flourish Gallery

As you work your way through this book, use this page to keep a record of all your favorite flourish variations. You may want to keep a dedicated notebook, as well. You'll be able to refer to your variations later for instant inspiration!

Fearless Flourishing

Acknowledgments

Loving thanks to my husband, Kamil, who has taught me to be brave no matter what we're facing, in both life and creative pursuits. Thank you for quietly whispering, "Courage, my love!" more times than I can count while I was creating this book (and for whisking the kids off on adventures so I would have quiet time to write). You're my favorite collaborator, and this book is for you.

Hudson and Emmalena, you are the bright spots of joy in my days; your infectious delight and sweet hearts buoyed me throughout this creative project. You are constantly inspiring me!

I thank you to my Mom and Dad for always lending your ears and hearts to listen and advise. To all of my family, I'm grateful for the endless ways you cheer me on, and not just for this book.

Much gratitude to my editor, Bridget Thoreson, and the entire team at Ulysses Press for helping me navigate the mysteries of publishing. Thank you for seeking me out for this project and everything you did to bring it to fruition.

Special thanks to Kyson and Cailey Morgan for dropping everything to assist me with photo set-ups, lighting arrangements, and general cheering as I tackled the photography for this book. And to my Mission Group friends, your gracious and prayerful support of this project is so appreciated.

Finally, I'm so grateful for the many friends I've made in the lettering community, and especially those of you who have been following along with Feist & Flourish Modern Calligraphy from the start. You have encouraged and inspired me to no end. Thank you for joining me on this creative journey.

About the Author

As the creative behind Feist & Flourish Modern Calligraphy, **Alissa Chojnacki** is smitten with all things hand-lettering and lives to #makesomethingeveryday. Alissa's delight in sharing the craft of lettering is palpable, from her scripty, illustrative, and floral-inspired works, which she posts daily on Instagram, to her lively Learn to Letter workshops, which she teaches locally in Vancouver, BC. With over a decade spent in the classroom, she draws on her skills as a professional educator; teaching others to letter is the highlight of her creative biz. As a wife and mother to two feisty littles, Alissa is inspired by family, faith, florals and flourishes, all of which figure prominently in her work.